SCOTSWOOD ROAD

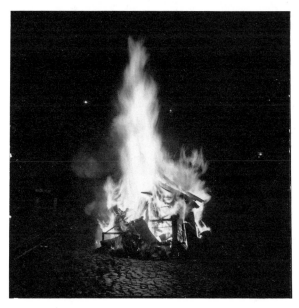

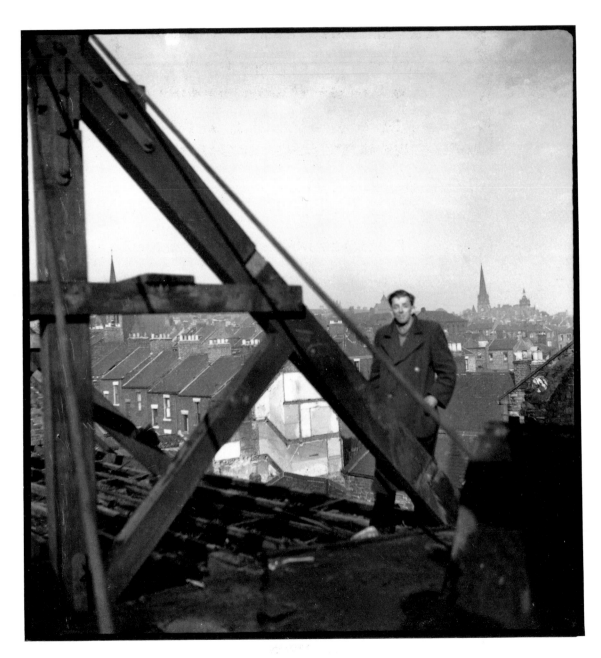

Jimmy Forsyth, 1960.

Scotswood Road

JIMMY FORSYTH

EDITED BY DEREK SMITH

BLOODAXE BOOKS
in association with
TYNE TEES
TELEVISION

ISBN: 1 85224 014 8

First published 1986 by
Bloodaxe Books Ltd,
P.O. Box 1SN,
Newcastle upon Tyne NE99 1SN,
in association with
Tyne Tees Television Ltd.

This book is published with the financial support
of the Arts Council of Great Britain.

Bloodaxe Books Ltd also acknowledges
the financial assistance of Northern Arts.

ACKNOWLEDGEMENTS

Scotswood Road grew out of the documentary *Jimmy
Forsyth: No Fancy Shades* produced by Tyne Tees
Television's Arts Features department and first transmitted
in 1986, and Side Gallery's exhibition *Scotswood Road*, first
shown in 1981. The historical pictures (pages 16 to 21) are
reproduced by kind permission of Newcastle City Libraries,
Vickers plc and West Newcastle Local Studies. The
negatives for the book were printed by Steve Bradwell. The
publishers also wish to thank Side Gallery, Des Walton at
West Newcastle Local Studies, and Peter McArthur, David
Reay and Peter Moth at Tyne Tees Television for their help.

Printed in Great Britain by
Balding + Mansell Limited, Wisbech, Cambridgeshire.

Foreword

Hard times, right enough. Times when a new coat amounted to something, and a hawker might still go to Appleby Fair by horse and covered cart. And with memory and the captions you might read through the details of another barer age on the shelves of Jack Reay's shop on the Scotswood Road. But the details are scarce, and something of a bonus. Nor are these mere documentary residues from the bad old days of living memory.

One photograph here which will eventually find its place in the books features the NORTH EASTERN REFRIGERATOR CO· LTD· (page 97), and Ned Campbell, Joe Wylie, Bob Atkinson and Bob Wilson. The names matter; they represent a new age living under the aegis of commercial signs set against an older culture of proper names and personalities. In these pictures Jimmy Forsyth honours existence before the Fall into Society. He is a portraitist whose world is peopled by named individuals whose myths might have been refined in the public bar of the Gloucester Arms. His successors – documentarists of urban scenes and of contemporary wastelands – register types, old-timers, representative housewives and children on the dump; they belong to the culture of surveys, enquiries and disclosures – an information-culture. Ned Campbell and the others waiting for the pub to open pre-date that signpost to the brand-named future.

Surely, he just took pictures of people he knew! Maybe, but look at Maurice Wilson by his 'good runner' (page 44) underneath the Osram sign on Water Street. Salesman and colleague mimic and give a rough life to the aethereal sign for 'the wonderful lamp'. And clearly he relished 'the monstrosity' unveiled by Messrs. Gaitskell and Smith, and subsequently sold for scrap. Out there the state and others promise better times on a large scale, but in the meantime there is the labour of this moment: that encumbered housewife on Gloucester Street (page 23) might be his motif.

'The people' make more than enough appearances in the photography of this century but hardly ever thus, as their own men and women. The difference is that they usually present themselves to agents of the higher culture rather than to someone also waiting for the pub to open.

Dan Wiener, the great American documentarist of the 1940s and 1950s, recorded the onset of corporatism in the United States, and might have made good use of Joe Wylie and the BENDIX sign. But Wiener's is an analytical,

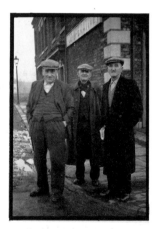

Outside Gloucester Street Co-op, 1957.

bird's eye view of the process, whereas Jimmy Forsyth in the 1950s belonged to those who were acted upon, and it is this which gives his pictures their quite particular resonance.

IAN JEFFREY

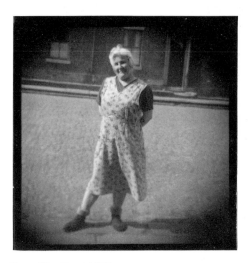

Dora Charlton, 1954.

Introduction

Descriptions of 'the old man who used to go round with a camera' rarely varied. At South Shields Library Doris Johnson remembered him as 'a frail old man' with one eye: 'He used to come in here with his albums selling prints, his wardrobe looked as if it came from the WVS, we wondered whether he ever got anything to eat. We haven't seen him for ages. He may have died.' In fact, at 73, Jimmy Forsyth was still clambering up 200-foot scaffolding to get better pictures.

Jimmy Forsyth began taking pictures with an old folding camera in Newcastle's celebrated Scotswood Road in the early 1950s. His collection is one of the most important records of a working-class community that anyone has produced – exhaustive in its scope, intimate in its detail. When he eventually took his albums to the local library at Elswick, local studies specialist Des Walton at once realised their importance. The old man was showing him a unique photographic study and social document, a portrait which could only have been made by a man who had himself suffered a lifetime of hardship. Des Walton indexed thousands of the pictures, and it has been largely due to his work in cataloguing the collection, and with the production of fine quality prints from the negatives, that the full extent of their value has now been recognised.

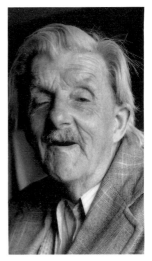

The Cedars, 1986.

Few people owned cameras in Scotswood Road in the fifties, and those who did could rarely afford to use them. So Jimmy Forsyth became their photographer, filling in the huge historical gaps left by the picture magazine and press photographers in their portrayal of post-war working-class Britain and what was to become of it. Jimmy's family portrait reveals a community poised uneasily beneath the town planner's sledgehammer, but still smiling.

His sole source of income was the National Assistance. He lived on the margins of poverty. Like the great Paris photographer, Eugene Atget, whom he resembles uncannily both in appearance and spirit, he tramped the streets selling pictures to the neighbours and building workers he had photographed 'for a few bob'. He always seemed able to sell the odd Boots-processed print to buy the next roll of film.

Jimmy was still taking his pictures as the streets were bulldozed away. His Boots prints documented the wholesale demolition of the Scotswood Road community, which ended with the redevelopment of far-flung estates and high-

rise flats. In 1962 he photographed T. Dan Smith with Labour leader Hugh Gaitskell unveiling a bronze statue outside the flats where he had himself been rehoused. This symbol of the new age of modernity and speculative building, nicknamed 'The Monstrosity' by the local people, disappeared one night, stolen by scrap metal cowboys.

Jimmy's cramped council flat is like a museum of the old community: photographs stacked in boxes; a piece of the old Scotswood Bridge on the wardrobe; his bedroom adorned with fragments of rock, cement, railway line, copper piping and street signs; and all kinds of memorabilia ritualistically placed, his spoils from the demolition. And each of these memorials to the buildings and bridges he pictured being demolished is identified by a neat handwritten card.

His photography in the streets of Newcastle has reached fanatical proportions. He has documented many of the construction projects of the past few years, day and night, and is treated as a celebrity by the many welders, engineers and labourers who have become his friends. 'The camera,' he says, 'has introduced me to an awful lot of people.' He celebrated his 70th birthday afloat when the crew of one of the Tyne's floating platforms decided to throw a party for him on the river.

But his privileged access to Newcastle's bridges and building sites has sometimes caused problems. More than once the police have been called out by people who spotted a suicide perched on a girder of the new Redheugh Bridge, only to find it was just Jimmy taking pictures from one of his usual hazardous vantage-points.

When Prince Charles opened the new bridge, and was being photographed by the media, the press and official photographers, Jimmy stepped out from the crowd and tapped him on the shoulder without anyone stopping him. The Prince turned round and Jimmy got his picture.

His passion is, in many ways, an epic adventure, like the romantic books he reads by the light of a 60 watt bulb, with a magnifying glass and his one eye – *The Life of Livingstone*, *The Search for Atlantis* – reminders perhaps of the years he spent at sea.

Few people would guess that this apparently frail, stooping eccentric saw most of the world as a young man. And looking at these remarkable photographs, few would think that their author was innocent of photographic techniques and aesthetics.

Jimmy has never really been interested in the *art* of photography, he has

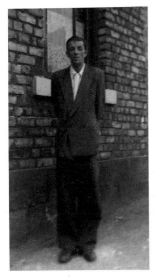

In Sunday best, 1955.

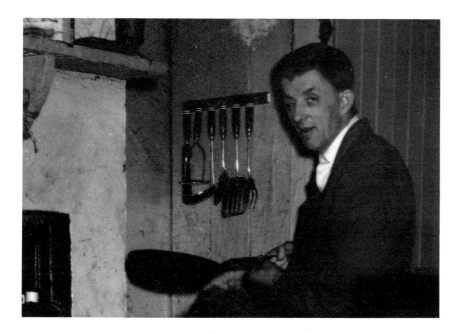

Frying an egg, 1957.

always relied on his own intuition. Discussions about composition are reduced to basic terms. Whether or not a lamp post sticks out of someone's head is the difference between a good and a bad photograph. And the quality of the tones? 'The fancy shades were there already, the sun put them there.'

He prefers to think of himself as the medium through which the community acted. And the evidence is in the hundreds of intimate portraits he made in the fifties. As Jimmy sees it, his people have nothing to lose or to fear; the images are an honest collaboration. Looking at these pictures now: this is exactly how they wanted to be seen, exactly how they would want to be remembered.

That entire culture disappeared during the 1960s when places like Scotswood Road throughout Britain were broken up. The Scotswood Road photographs constitute a singular event in the history of photography: a community which has chronicled itself.

Jimmy Forsyth's life work celebrates all those people who lived and worked in Scotswood Road. I asked him once how *he* would like to be remembered and, without a trace of sentiment, he replied: 'As an honest citizen.' We were looking out at the hopeless landscape surrounding his council flat where some

youths had thrown bricks at him, injuring him so badly that he needed hospital treatment.

'Something has gone wrong,' he said, trying to make sense of what had happened. And then back to the old days: 'We were happier then.' Yet he does appreciate the absurdities of a society whose achievements are demolished twenty years before the loans taken out to finance them have been paid off.

One day when I was assembling material for this book, I arrived at Jimmy's for another session with the tape-recorder. The previous day he had talked about his life. Before I was through the door, he told me the flat had just been burgled. I braced myself for the worst, imagining the sideboard ransacked, the unique set of photographs missing, his surreal museum desecrated. In fact, the intruders had found only one thing of value to them: Jimmy's electric kettle.

The man whom Dan Smith called 'a philosopher of great significance' lives simply. For Jimmy, survival means getting over the next electricity demand. Next to the photograph albums, his most valued possession is his bus pass.

DEREK SMITH

Gallowgate, Newcastle, 1955. Leazes Lane is off to the right.

'I wasn't looking for fancy shades'

I came up to Newcastle in 1943. They were shouting for fitters at Prudhoe, so I volunteered, and came down here from Glasgow where I'd been working for two or three months. I lived in Barry in Wales.

But after that I never went back.

What sticks in my mind most about coming here is that I couldn't understand what people were saying for a long time, they seemed to speak that quickly and before you could understand what they said, they were on to the next bit. But we spoke the same language really. Barry was an industrial place like other parts of South Wales. With that sort of background I settled in and got on all right with Scotswood people, there was always a friendly atmosphere about the Scotswood Road area anyway.

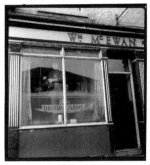

Gloucester Street, 1958.

People were clannish and banded together for strength, I saw that in the pubs most of all. Pubs like The Gun, Hydraulic Crane, The Vulcan, Forge Hammer and The Blast Furnace, their names reflected the work but also said something about the strength of the community. Pork pies got me an introduction to the pubs of Scotswood Road, all 44 of them. The family I lodged with made pies in their back kitchen and sent me out with a basket, hawking at night, it always came back empty.

The food was all right, despite the rationing, but the houses weren't very good, if you wanted some water you had to go outside with a bucket, the tap was in the yard. The toilet was out the back of course, and you'd either go to the washhouse for a bath or use the washtub in the yard, there was no room in the house. They used to bath outside in the winter too, and if there were a lot of young lassies in the household the men would go to the washhouse down the backlane. People took all that for granted I suppose.

You only start worrying about your privacy when you get posher things like baths in the house.

And it's worse when the bath's in the house because the worst thing about these new houses is they put the toilet and the bath in the same room, and then if you're dying to go to the toilet you can't because the lass is in the bath. It's stupid, that.

You know if it wasn't for my accident I'd probably never have photographed Scotswood Road. I was in the boilerhouse at Prudhoe when a piece of chisel broke off and caught my pupil, they tried to save the eye but the cut was

too deep. I felt really bad until I looked around me in the hospital and saw some of the other cases, I thought well, there's plenty of people worse off than me, much worse. It made it difficult to get work after that though, you're a bit of a liability with one eye in a machine-shop.

I never worked again.

With my small amount of compensation, a couple of hundred pounds I think it was, I bought a general dealer's business on Scotswood Road. That lasted three months until I was hoyed out. I knew most of the customers and I'd say, 'Oh, poor Jock's wife, he's out of work again, I'll help her out this week', and that would be another fiver down the drain. I let so much out on tick, there was no money to pay the bills in the end. I worked out I'd given most of the stock away, all I had left was the Avery scales and the bacon-slicer, I got a few pound for them.

Then you know how it is, at first you look for work everywhere and then you realise there isn't any, so you don't look so hard after a while, and then you stop altogether.

No one wanted a one-eyed fitter.

There were a lot of others hanging about the street corners in the fifties.

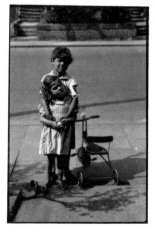

Westmorland Road, 1956.

So that made me feel a bit better. I settled down to life on the Assistance at 353 Scotswood Road and got used to secondhand clothes and going hungry now and then, like a lot of others. I'd been out of work in the thirties but escaped to sea then, as a fourth engineer, that's when I saw Japan, both the big canals, and nearly got drowned in the Pacific.

I had a right look round the world then, like.

The early fifties were bad, I had to sell off odd bits and pieces. Some, like the history books on Newcastle I'd treasured, because I liked to read up a lot about the place I'd adopted, especially what background I could find on Scotswood Road. I had an antique glass bowl, blue and white like a little sugar bowl, and I knew it would get smashed when I was moving from place to place, so I sent a letter off to Lady Ridley and said if you want this piece of glass you had better come and get it because it will probably get broke if you don't, and when she came and looked at it she said how did you know I collected Sunderland ware. She offered to pay for it but I wouldn't take anything because I was obstinate, I said I'm as good as her, so I told her you wanted the bowl and now you've got it. People said you can't talk to people like that, but I did, and she was all right too. She came in a big car with a chauffeur, there were lots of heads sticking out the windows down the street to see who it was.

People still talk about the day Lady Ridley came to Scotswood Road to see Jimmy Forsyth.

It would have been just after that a young man in a state knocked at the door around midnight, he said 'Can I come in and sleep the night because my father's hoyed me out'. So I took him in like, and let him lie down on the couch, and he could have shot my head off in the middle of the night for all I knew. I don't think what I did was unusual, that was the sort of spirit then, there was nothing to pinch anyway, most of the nickable wealth in my house and neighbours' houses was in the gas meter.

Plans were already in the air for knocking Scotswood Road down.

Once that was about, the landlords neglected the properties, some houses never got a lick of paint for years, roofs leaked, bedrooms were damp, they let the place slowly go to the dogs. When they knocked down the Infirmary in 1954 a curious crowd gathered to watch.

It was then that I realised someone should make a record of what was left of the community. For posterity's sake, like. I had nothing to do, why not make a record of Scottie Road to pass the time? It would show future generations what we looked like and how we lived.

I wonder how I ever made the pictures, I was only on a couple of pounds Assistance then. Anyway, I picked up a cheap folding camera in one of the pawn shops. There wasn't much to adjust, just as well, because I'd never have known what to do. I still can't understand exposures and things like depth of field after all these years, not really. I'm just an amateur.

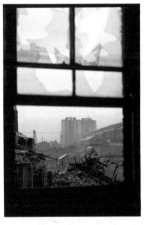

From Park Road, 1960.

First I recorded all the street corners, that's where all the activity was and there were dozens of streets running off the road, it was three miles long. You had to get back about 45° from the end of the buildings to get them all in, but not having a wide-angle lens sometimes it was impossible to get far enough back, so I took pictures from both ends just to make sure.

I was never interested in photography, not really. When you're taking a photograph you're recording something that will never happen again, catching a moment in time, I was just capturing what I knew was going to disappear. People say to me today, 'How did you get all those fancy shades?' but I wasn't looking for fancy shades, I was just taking what was there, the things I was interested in and the things I liked, and tried to make them look real.

All the developing was done at the chemist's, I could only afford contact prints – I had to wait twenty years before I ever saw the negatives enlarged or

13

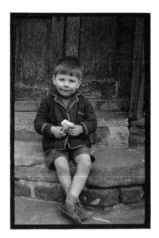

Ralph Liddle, 1958.

printed properly.

Later on I took a few snaps of mates and people roundabout, not many Scotswood Road folk had cameras so this was a bit of a novelty. I sold the odd print now and then to buy more film to be going on with. To add to my collection of views which grew bit by bit I began doing portraits. Nobody minded, I probably looked that harmless anyway, I sort of knew everybody, it was something like a family portrait. No one asked where I was from and what was going to happen to the picture. Just like it said on my Assistance Card, I was James Forsyth esquire, number 353 Scotswood Road.

I photographed the demolition of the old Noble Street slums in 1956 and the building of the new Noble Street flats, the first bit of the new redevelopment along the road. I never thought I'd live to see them being pulled down but I did, just 20 years later. A mate's wife went down to look at one they'd been offered in 1963, it shows what was thought about Noble Street flats, even then, someone had flung shite onto the ceiling, like. When she got back to the housing office she told them she couldn't take it in that state. The clerk snapped at her: 'You people, *you people* are lucky to be *offered* houses.'

Somewhere, I have some family, but I don't know where they are now. My father worked the railways in Barry, a guard got three or four pounds a week then, which was canny pay in those days.

A fitter got three pound twelve.

He wouldn't have tickets my father, he never wanted anything unless he had money to pay for it. If you can't work, starve, he used to say, if a man can't earn his salt he shouldn't bloody have it. My mother wouldn't have anything modern, she didn't like women painting their faces, said it was unnatural.

When I lived down home, it wasn't like it is now, you could go out in the country, walk for half a mile and you were out in the woods, or you could go down the coast and play on the beaches, go hunting for crabs and sea shells and that.

At school I never went in much for the football caper, I'm afraid. I was skilled enough in class, but I didn't go up to the higher school, we didn't want to mix with the snobs. When you were 14 you left school in those days, and you were expected to look for work straightaway because people relied on you for money. But there was no work about, it was that bad really in the thirties. I was living at home and after I'd finished my apprenticeship I decided I would go to sea. I probably thought it was a bit of an adventure, or maybe it was a change, or it could have been wanting to work where nobody could tell you what to do.

In those days you listened to your parents, and if you lived at home you did what you were told.

It wasn't like now when they go out and smash windows and things like that, we wouldn't have dared.

I hardly know anyone here in The Cedars. Something has gone wrong somewhere. It doesn't bother me, I'm out on the streets most days, walking, watching, meeting people, still taking a lot of photographs. I'm doing a series on street traders right now. I'd have a terrible job getting to sleep if I didn't go out. You've got to work yourself tired.

There's not much recorded of the working class, not really. I'm pleased when people pull me up in the street and say, 'Are you the man who took all those photographs?' It gives you a bit of pride in yourself.

JIMMY FORSYTH
as told to Derek Smith

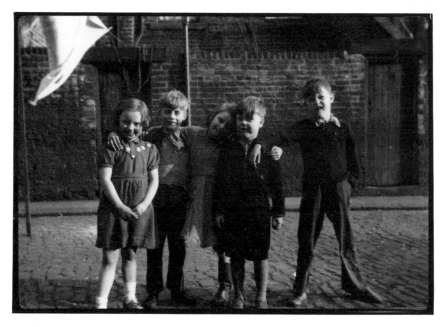

Angela Pearce and friends, Scotswood Road back lane, 1956.

Scotswood Road

Scotswood Road was born in the 1850s out of the invention of a revolutionary weapon. The breech-loaded artillery gun, unveiled by Newcastle engineer George Armstrong in 1855, came too late to affect the Crimean War. But the government recognised its power to transform warfare, and gave Armstrong lucrative contracts. Scotswood Road was built to house Armstrong's workers.

Its densely packed streets ran down the hill to the vast armament factories, which stretched along the three-mile length of the road from Scotswood to Elswick. Celebrated in Tyneside's folk anthem *The Blaydon Races*, the road was as notorious for its pubs as for its people. There were 44 pubs – one on every corner. The people were tough, the community was close-knit, and the men were hardened to long spells out of work.

Armstrong, a qualified solicitor, opened his Elswick works in 1847, built bridges and invented an ingenious hydraulic crane. The expansion which followed his move into armaments was remarkable. The workforce grew from a hundred men (he is said to have known each by name), to 20,000 by the turn

Sir G.W. Armstrong, *left in top hat*, with General Ulysses S. Grant, *5th from right*, at Elswick works, c.1870.

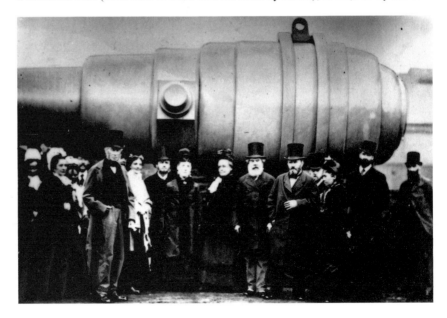

of the century. They came from all over to work in the yards, driven from rural struggle in Scotland, Ireland and England, and from cities where work was less secure. Within fifteen years the population of Elswick had risen from 1800 to 14,000. By the end of the century it had reached 60,000.

Elswick shipyards opened in 1883, and Armstrong became the world's most successful exporter of warships. Between 1884 and 1914 eighty-four ships were launched, many of them battleships. Foreign delegations frequently visited the yards to commission or launch ships for their navies, some of which would later fire on each other in the naval conflicts of the First World War. The order books suggest that such exchanges may have happened in a number of battles. In the ten-year build-up to the First World War, eight major navies spent £670 million on warships. A significant proportion of their orders went to Elswick, which could build an entire battleship from raw materials on site, with steel plants, engineering works, ordnance factories and plenty of cheap labour all under virtually the same roof.

Armstrong died a baron in 1900, soon after opening his second factory, at Scotswood. The picturesque Low Elswick village and the whole area spreading

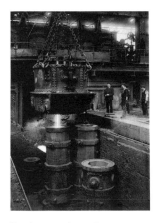

Casting gun barrels, Elswick, c.1890s.

Salmon fishing below Scotswood Bridge, 1913.

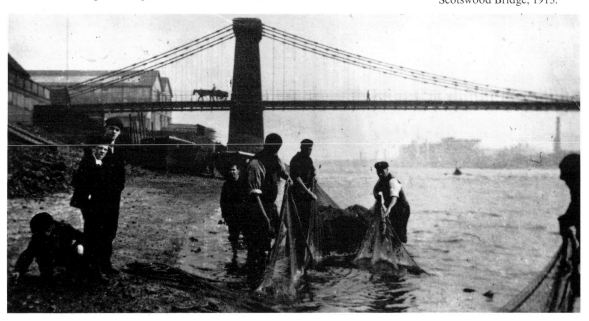

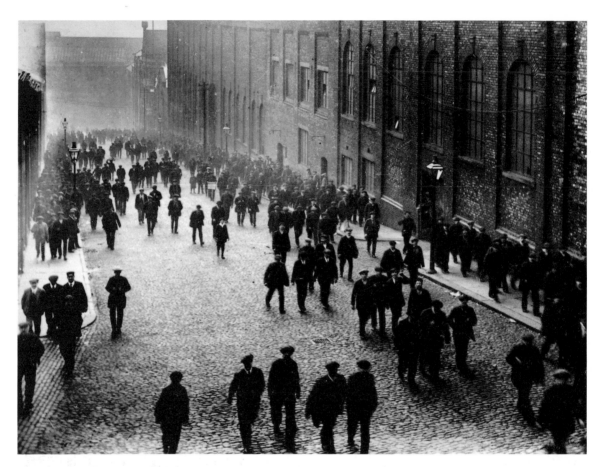

End of shift at Elswick works, Water Street. No. 353 Scotswood Road was at the top of the bank.

out up the grassy slopes from the Tyne were soon to be transformed into machine shops and industrial terraces. The salmon once caught in abundance disappeared as the Tyne became heavily polluted. The First World War saw Elswick and Scotswood at their peak, with a third of Britain's guns produced by the workforce of 25,000 men and women.

The armistice brought unemployment, wages dropped, and women who had become skilled workers during the war found themselves back in their kitchens. Scotswood Road's scarred and limbless heroes returned to a depression that was to last until the mid thirties.

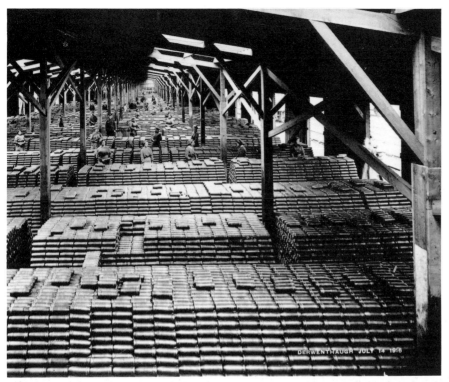

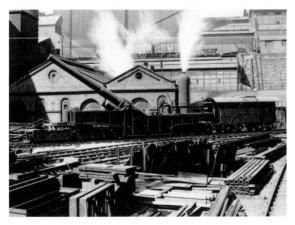

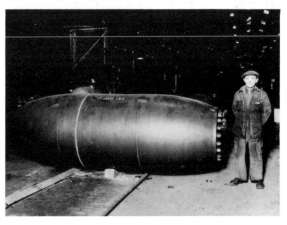

Left: Shell cases stored at Derwenthaugh, July 1916.

Bottom left: 12″ howitzer, Elswick, 1916.

Bottom right: Five-ton bomb, Scotswood, 1945.

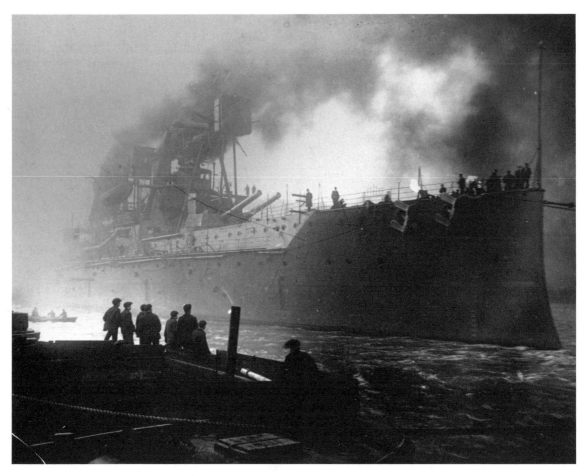

Launch of HMS Superb, 1907.

Armstrongs had to diversify their work, and soon cars were being built in the Elswick and Scotswood factories. A bigger move into locomotive production was badly hit by a fall-off in orders from the railway companies, while the acquisition of a Canadian paper mill lost millions. However, demand for tanks increased again during the early thirties, and workers who had been laid off were re-employed.

As well as Vickers-Armstrong – as it then became – there were five pits in West Newcastle between the wars, at Elswick, Benwell and Scotswood. The

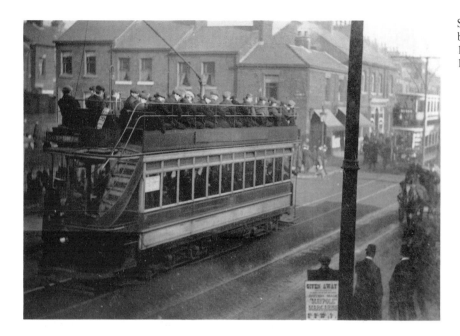

Scotswood Road,
bottom of Park Road.
12 noon, Saturday
12 February 1910.

Montagu Caroline pit at Scotswood survived until 1958. Its partner was the View pit, where 38 miners were drowned in 1925 after breaking through to a flooded seam. The Montagu management had kept no plans of the workings that riddled the banks of the Tyne. Dependants of the victims turned down the management's first offer of £90 compensation, eventually agreeing to accept £200, roughly what a hewer would earn in one year.

Re-armament and the build-up to the Second World War brought full employment to Scotswood Road for the first time since 1918. But when the last batch of Scotswood five-ton bombs dropped on Dresden and Hanover in 1945, the men who had made them were preparing themselves for another slump. When Jimmy Forsyth took his first pictures of Scotswood Road, the place was already in decline. Today traditional industry has almost completely disappeared. In their high technology tank factory at the end of the road Vickers employ just 750 people. Some parts of Newcastle's West End now have 30% unemployment.

D.S.

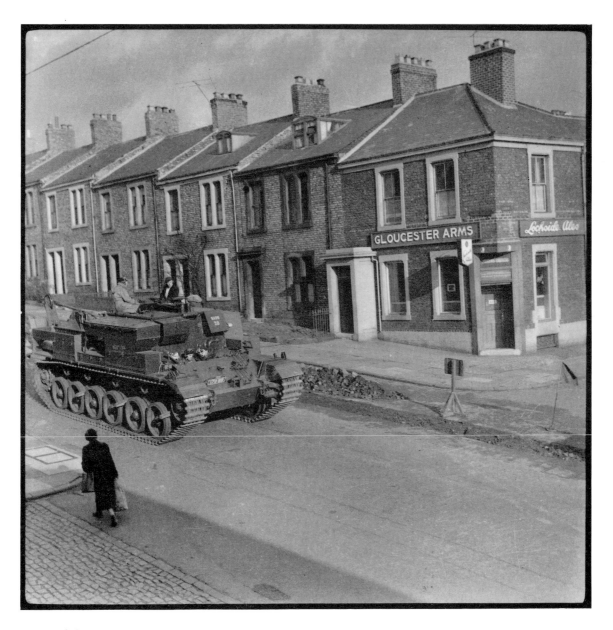

January 1957.

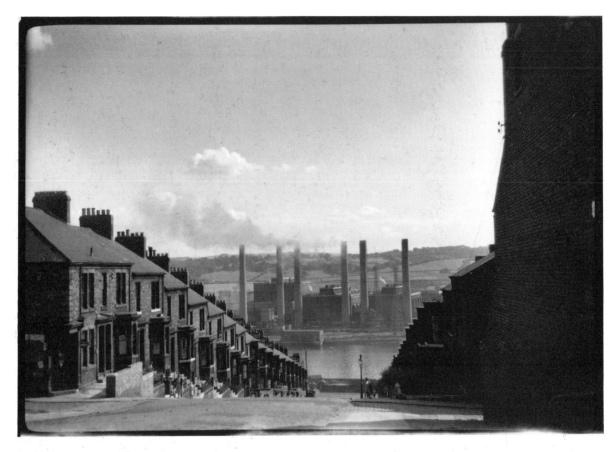

Dunston power station, November 1955.

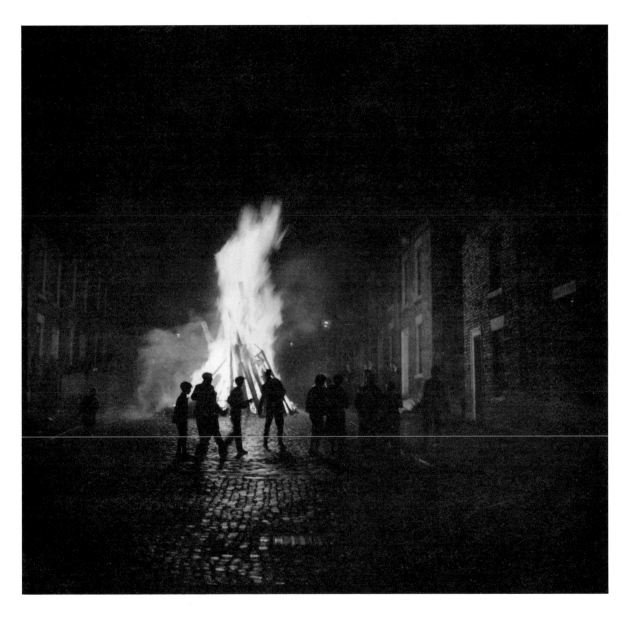

Charlotte Street, 1957.

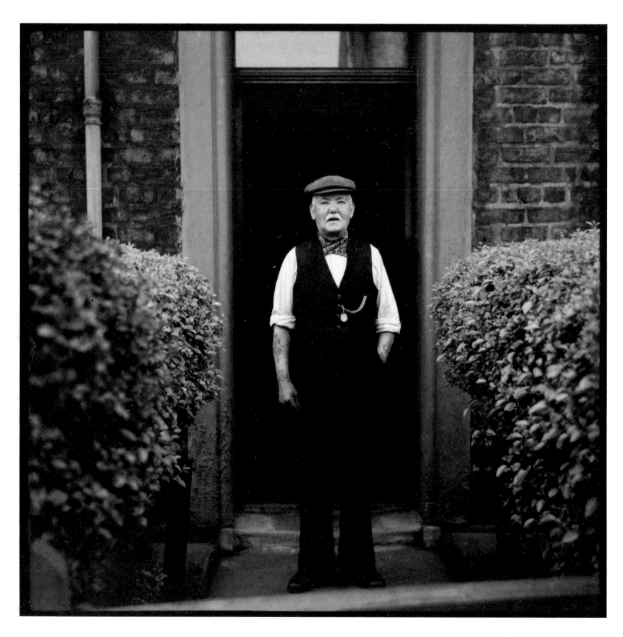

29 July 1957.

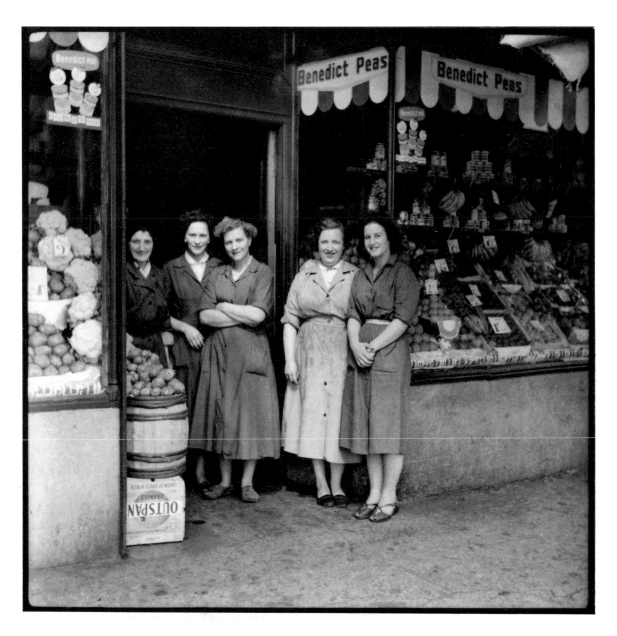

Gibson's fruit and veg, Scotswood Road, 1958.

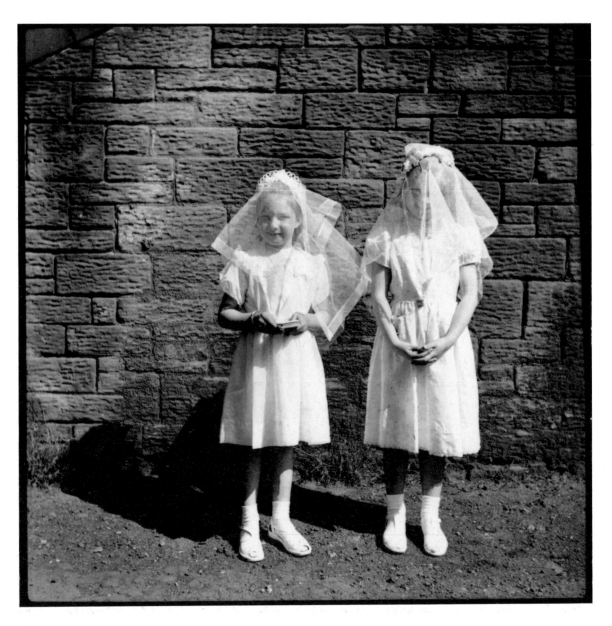

1957.

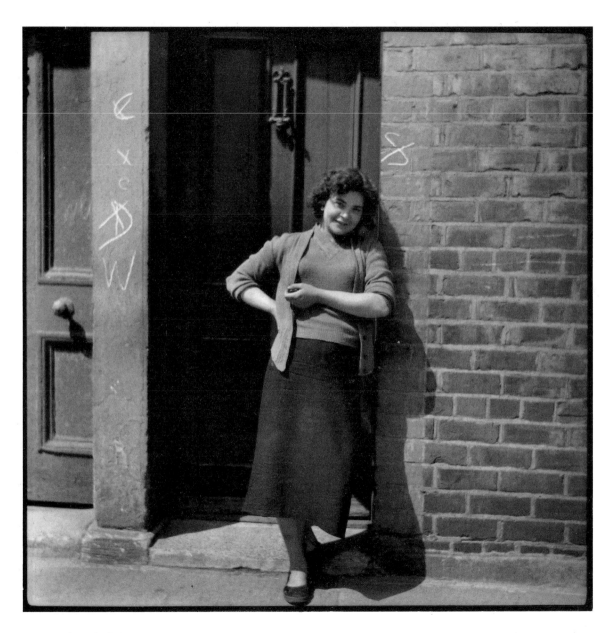

Scotswood Road, 1958.

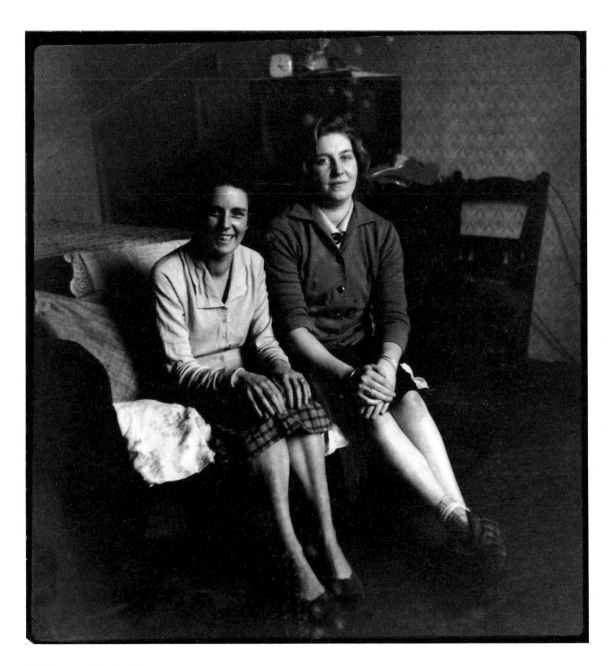

351 Scotswood Road, 1958.

23. A tank in Gloucester Street on its way back to Vickers from tests at Otterburn. The vibrations made the whole street shudder, I think they tested the houses as well. The back room of the Gloucester was a good place to enjoy a sing song.

24. The east end of Scotswood Road wasn't so bad, but as the streets ran towards Vickers-Armstrongs and the west they got steeper. Clara Street was very steep. Now it's gone, and so has the power station.

25. The spectacle of dozens of bonfires, one for every street, is one of my fondest memories of Scotswood Road. They seemed to get bigger as the demolition began because there was more wood to burn. No one bothered about safety, we just built them in the middle of the street. Now they've got some fancy regulation that makes them illegal.

26. He lived in Cambridge Street and used to go to sea. He asked me if I'd take a photograph for his two daughters as he knew he might not be there for ever. Lots of men dressed in that Edwardian fashion they'd been used to and couldn't find the reason, or the money, to change.

27. I used to go there for things I wanted. I said one day to the ladies, 'Would you all like your picture taken with the shop?' Mrs Gibson got all the staff outside so they could all be in the picture, that's her on the left.

28. Confirmation, Sunday. St Michael's Church.

29. Betty Young on her doorstep.

30. Mrs Joan Curry is on the left with her sister-in-law in the flat above mine.

Mrs Gladders said: 'They're going to knock Scotswood Road down, someone should make a record of it before it all goes to dust.'

I recorded what people were familiar with. No one ever said it, they didn't need to, but all those tatty shops and pubs and houses made up their roots.

I bought a snapshot album with a tartan cover and pasted in photographs of all the street corners along Scotswood Road, for posterity.

33. Suffolk Street from Scotswood Road, 1958. The London and Newcastle Tea Company is on the right.

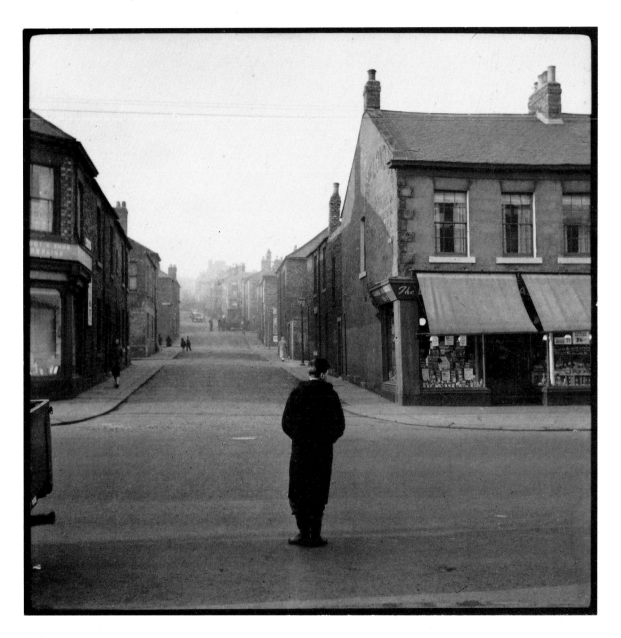

1958.

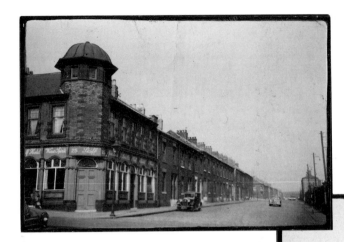

The Skiff, Railway Street, 26 March 1956.

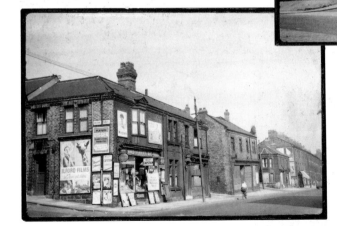

The Forge Hammer, Edgeware Road, 1956.

Best's shop, Frank Street, 1956.

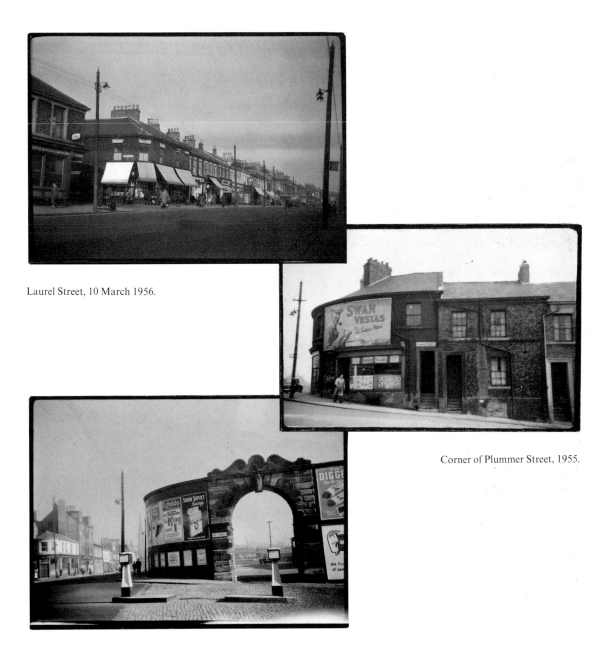

Laurel Street, 10 March 1956.

Corner of Plummer Street, 1955.

Cattle market on Ord Street, Winter 1956.

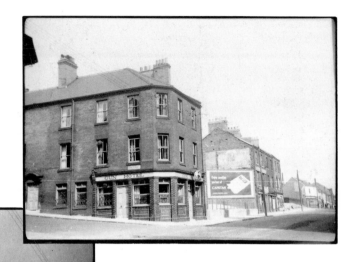

The Gun Hotel, Enfield Road, 1956.

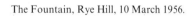

The Fountain, Rye Hill, 10 March 1956.

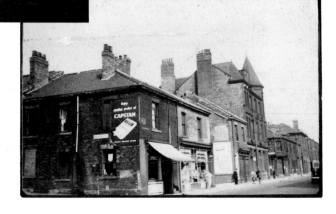

Greenhow Terrace, Elswick Hotel on right, 1956.

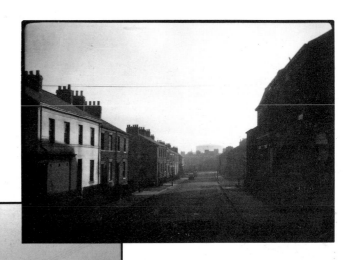

Near Blenheim Street, 15 March 1956.

Alexander Street, 1956.

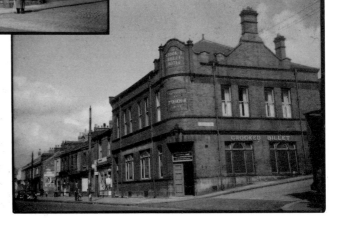

Crooked Billet, Glue House Lane, 1956.

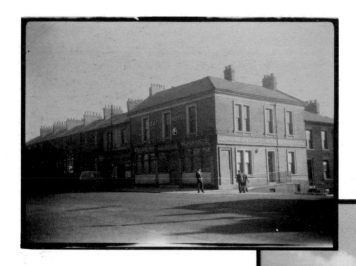

The Bath Hotel, Dunn Street, 1956.

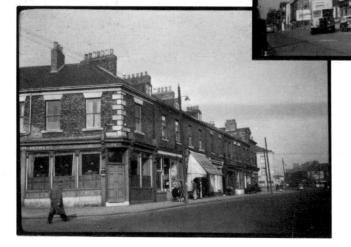

Maid of Derwent, Maple Street, 1956.

East end Scotswood Road, 1956.

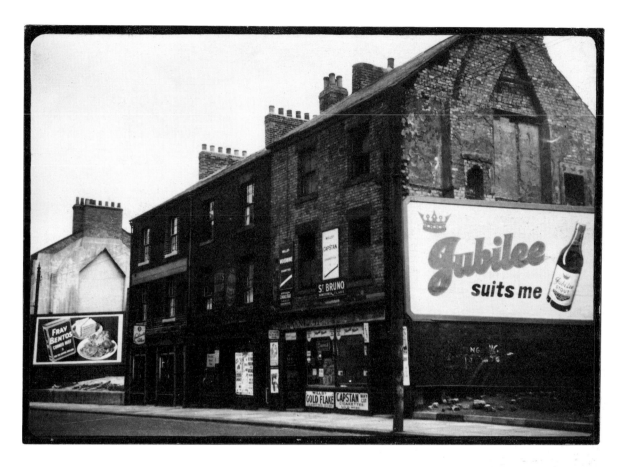

89–91 Scotswood Road, 1956.

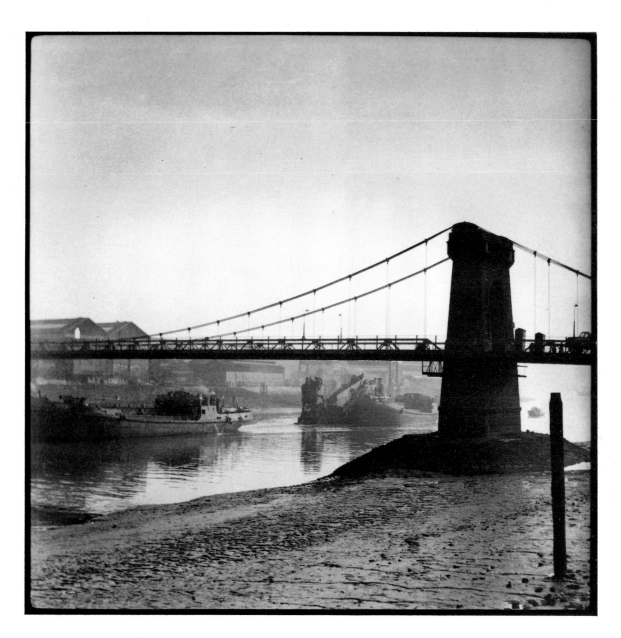

From Derwenthaugh, 1959.

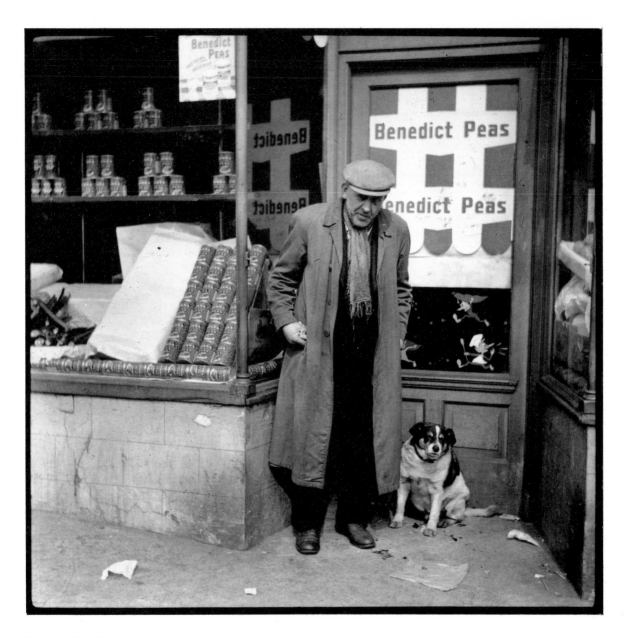

Scotswood Road, May 1957.

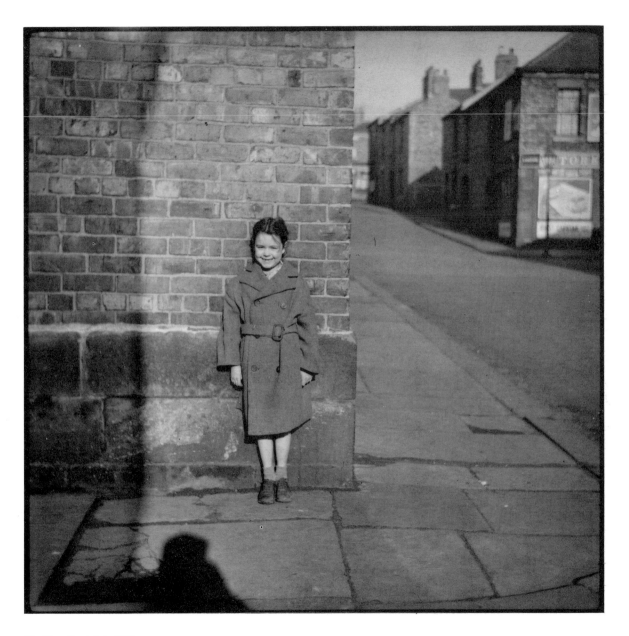

The New Coat. July 1958.

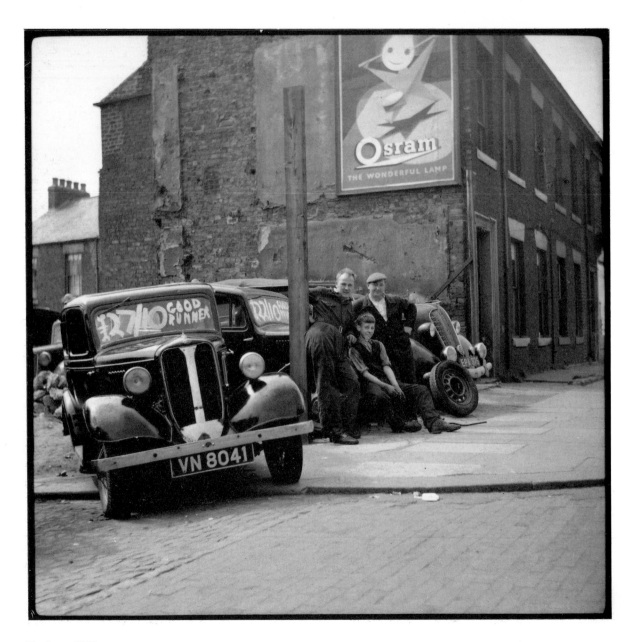

Used cars, 1957.

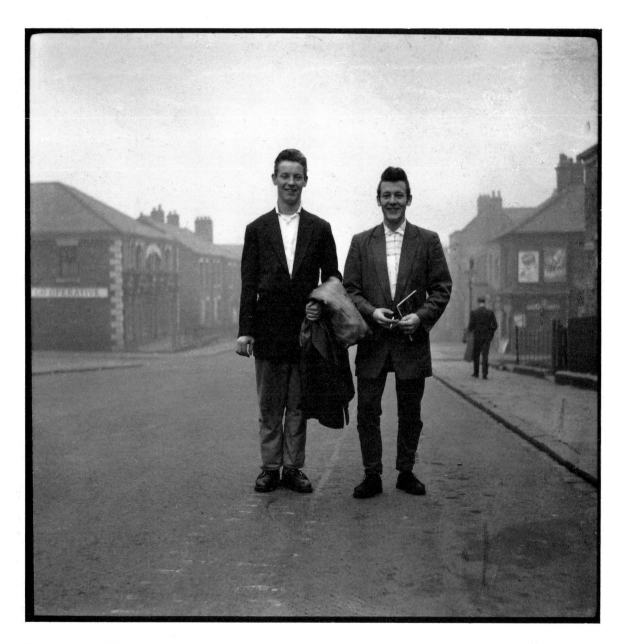

Gloucester Street, 1957.

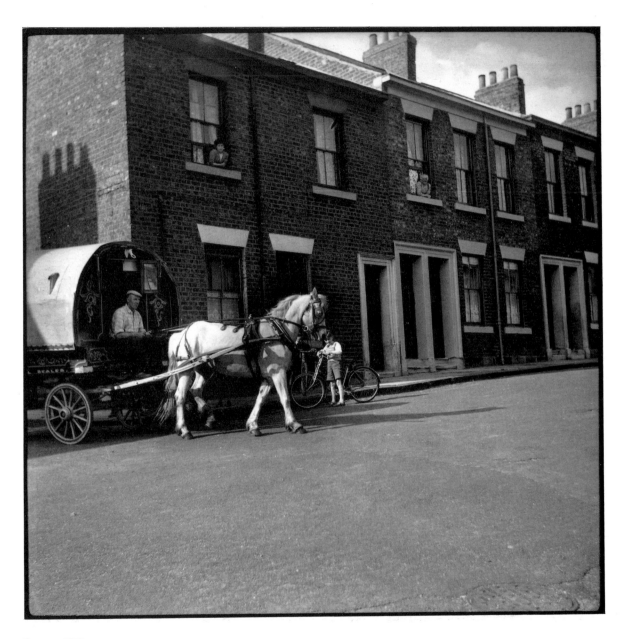

Summer 1957.

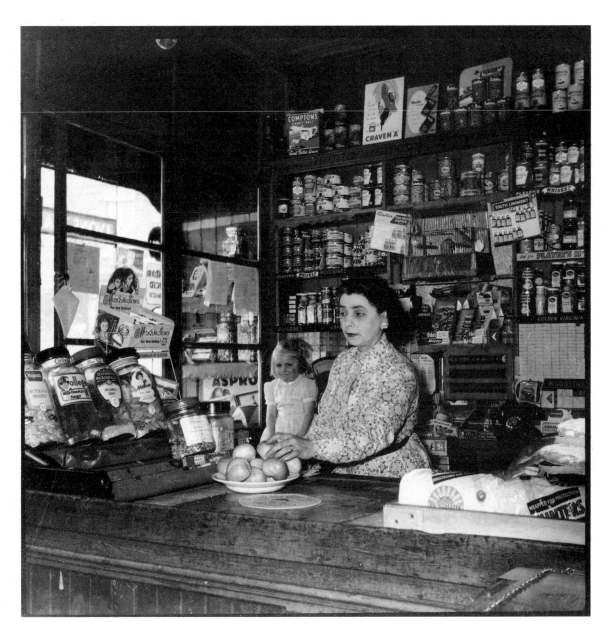

April 1957.

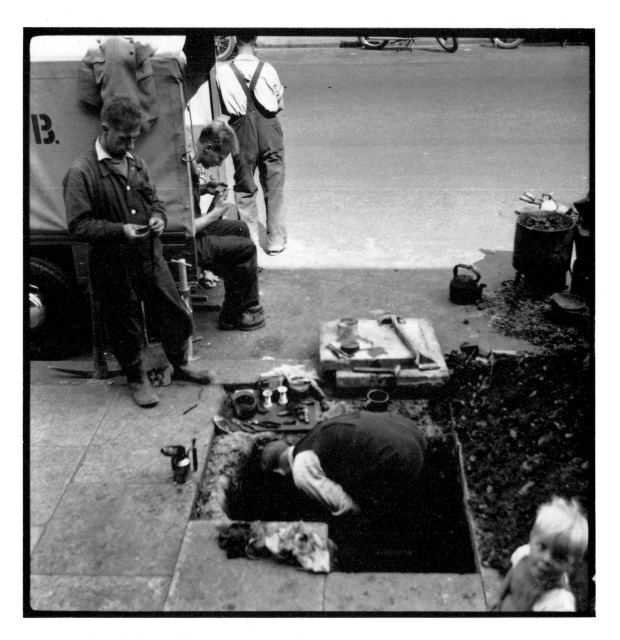

Workmen outside Forsyth house, 1959.

41. The 1831 Scotswood Bridge at low tide. I took it from the south side one Sunday morning to include Vickers' Scotswood factory. Below is a dredger, being towed by a lighter.

42. Bob Atkinson, Gibson's fruit and veg shop one Sunday, waiting for the pub to open. 'There's Bob with his dog, he never treats it right,' people used to say.

43. Maureen Beveridge on the corner of Oak Street and Suffolk Street. Sometimes I like to see my shadow, it shows that it was me that was taking the picture.

44. Maurice Wilson is the man with the cap, on derelict land no one wanted at the top of Water Street. If a few houses were empty they were knocked down soon enough, and that was part of the demolition done. Half a street or a quarter of a street would go, the spaces were just left mostly. As you can see in those days you could get a good used car for twenty-seven pounds and ten shillings, you wouldn't get a tyre for that now.

45. Ticket men, or tally men, came round the houses on Thursday nights collecting for the credit shops, people got tickets out for say twenty or thirty pounds to get themselves clothes. Todd Brothers and Waterloo House were two of the main places where you got clothes on credit. A lot of people relied on the never never. Those marks on the road were made by one of the tanks.

46. Jock Liddle the hawker driving his caravan from the back of Scotswood Road into Penn Street. Every summer he'd take the family across to Appleby horse fair in it.

47. Peggy Moore ran Jack Reay's shop on Scotswood Road, just to the west of Hare Street, that's her granddaughter sitting on the bench. She kept a budgie in a cage, it's just behind her, next to the tooth liniment. Shops like this stocked small amounts of just about everything you needed, even if they didn't sell well. In these big modern shops you can't get nothing. I know nobody uses step stones now, but a wife used to have to stone her steps, and there were other things she'd want that you can't get now, like toothache tincture.

48. N.E.E.B. men at work on Scotswood Road just outside number 353.

51. Outside Nailer's shop on the corner of Pine Street and Suffolk Street. Freddie Palmer on the right and Sandy Skinner, he was a long distance lorry driver, they used to go about together a lot.

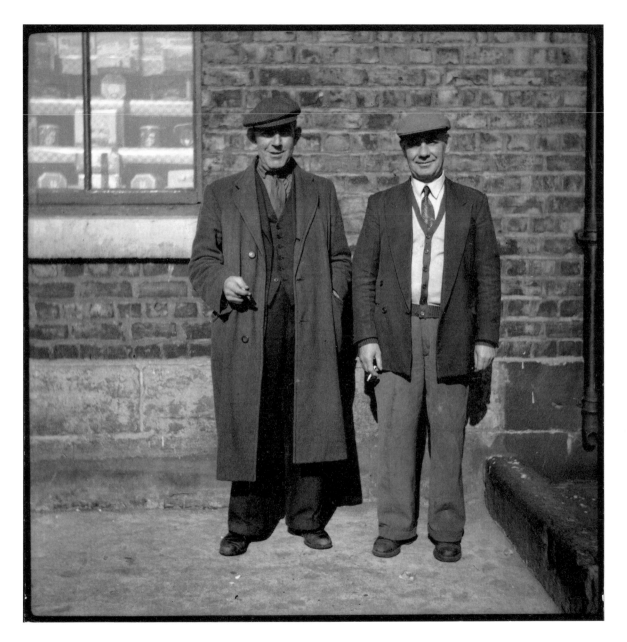

Companions, 1956.

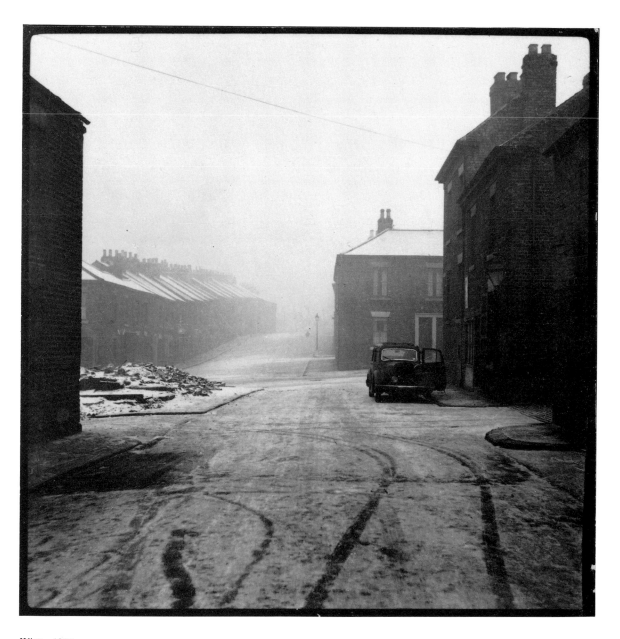

Winter 1956.

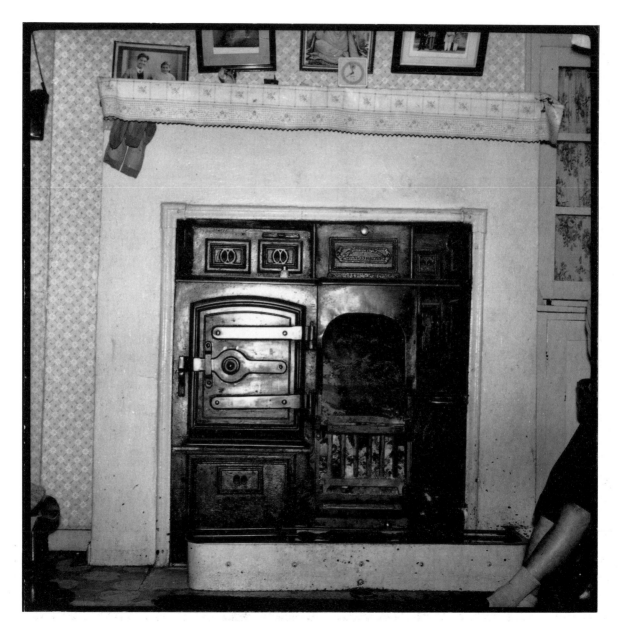

Living-room, 1958.

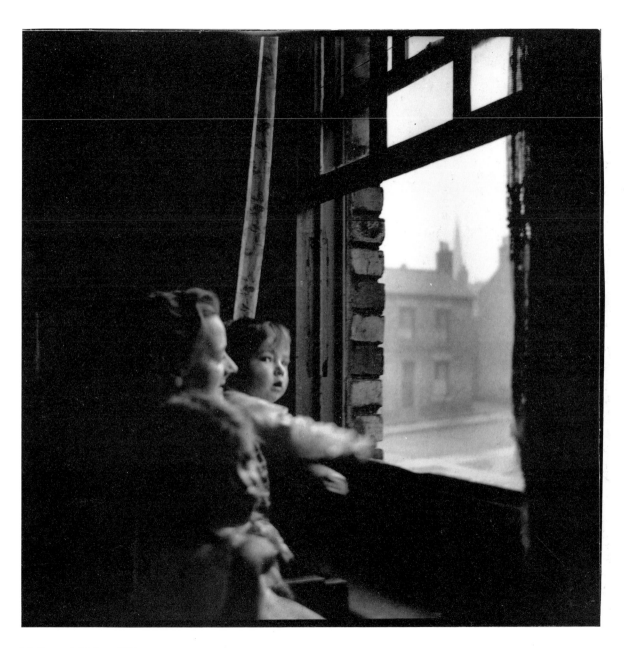

Mother and children, 1957.

TO21259

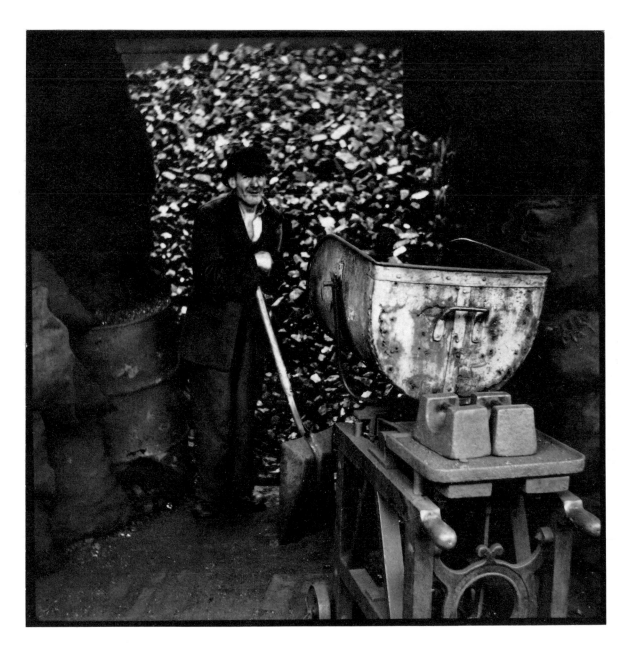

September 1957.

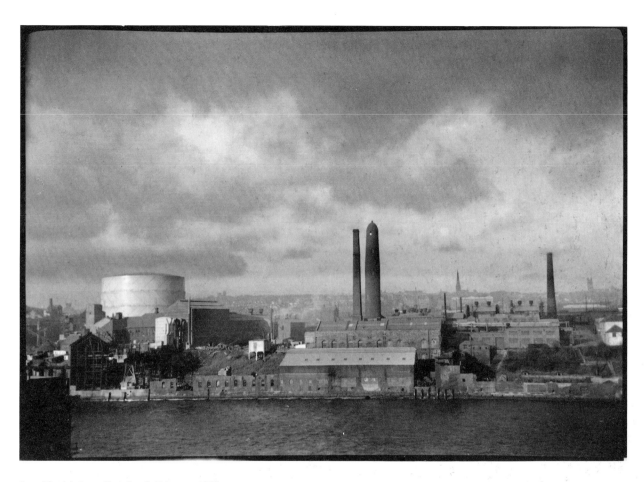

Low Elswick from Gateshead, February 1956.

53. A quiet winter Sunday on Brunel Street looking up past McCormick's shop and car to Penn Street. Hardly anyone had cars except some of the better-off shop people. Opposite, the ruins of another shop that had been boarded up since the end of the war.

54. Range in Singh's house, Delaval Road Estate, the Singhs were some of the first Asians to settle in Newcastle.

55. Dot and Andrew Beveridge with their mother. The house was on the corner of Gloucester Street and Pine Street. These three-roomed Tyneside flats were never suitable for bringing up families in but most did, some with families of seven.

56. A Scotswood Road man, Jimmy Wilkinson, at work filling sacks in Ned Grey's coalyard in Railway Street.

57. Industrial landscape, northwards across the Tyne, this is the start of Scotswood Road. The tower at Elswick leadworks produced shot for the Napoleonic wars. The last to survive in England, they tried to repair it but something went wrong and it collapsed.

59. Fire at the Prendergasts' house in Pine Street when a settee caught alight. There were a lot of settee fires in those days.

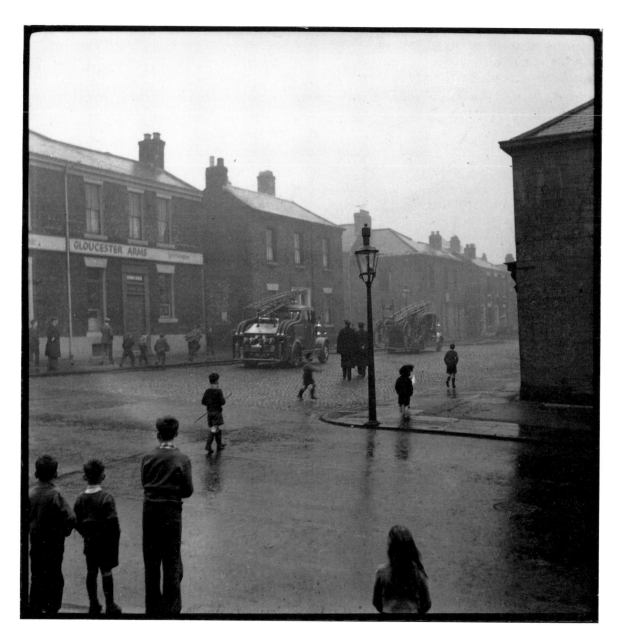

A fire, 1959.

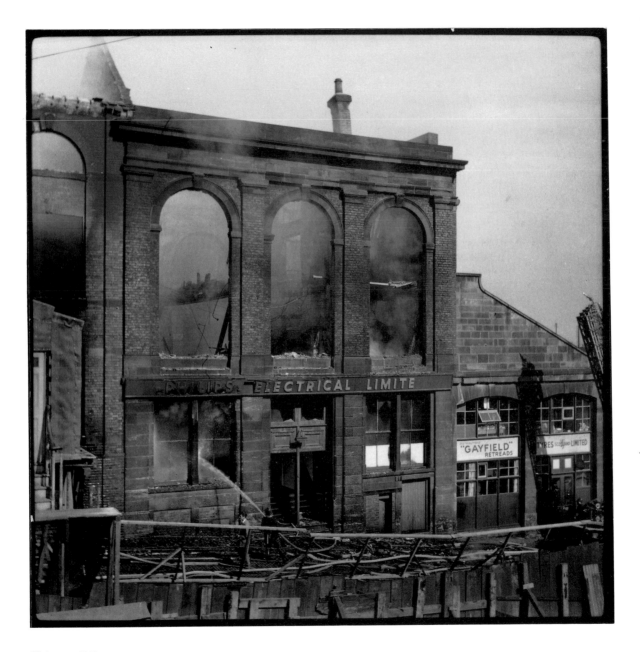

17 August 1959.

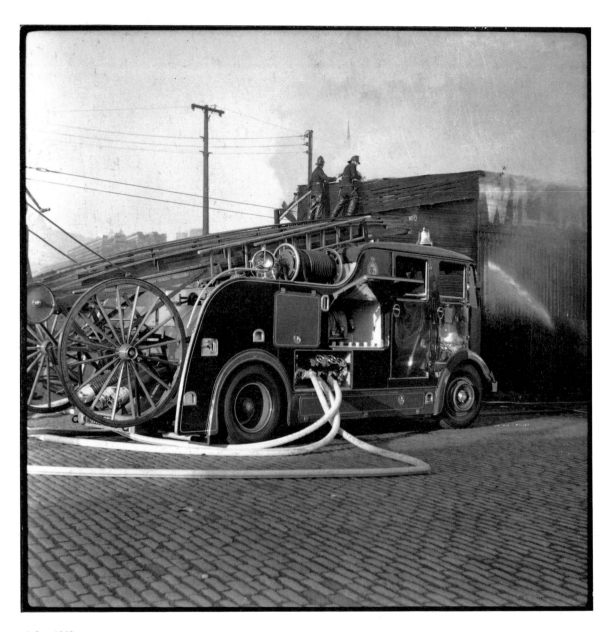

A fire, 1959.

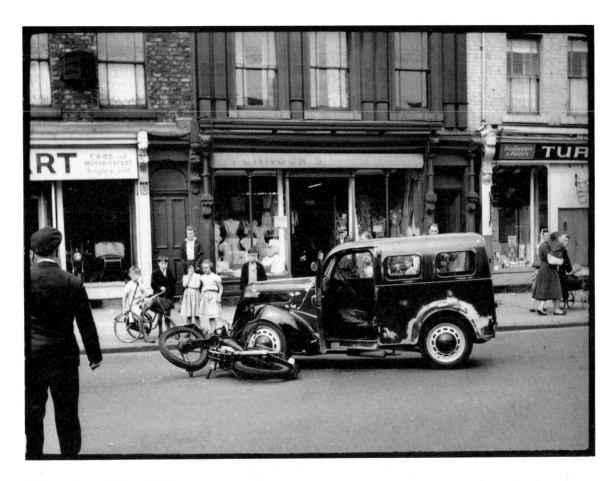

Scotswood Road, 28 August 1958.

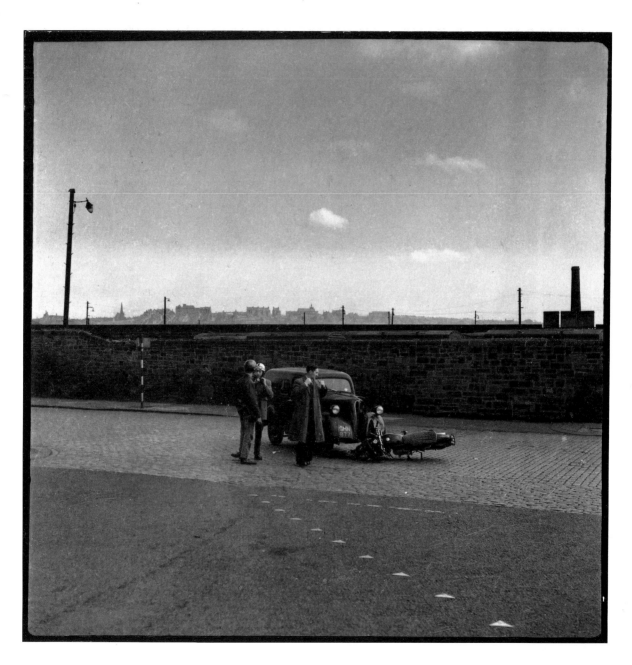

64 Accident, 1960.

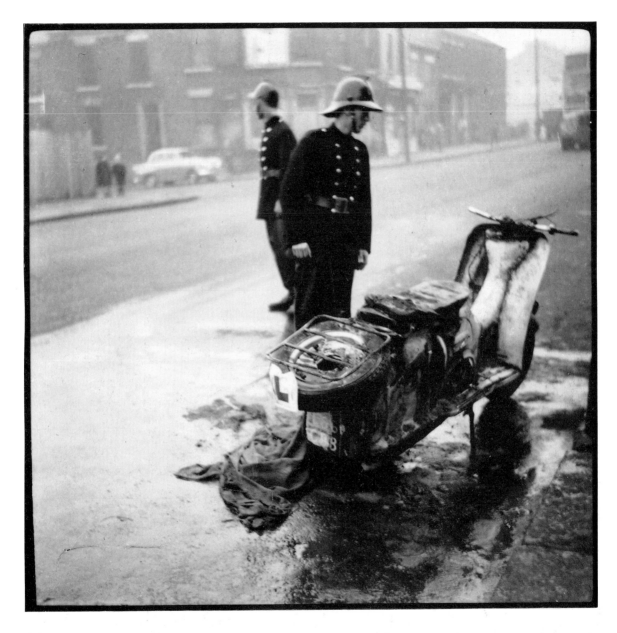

A fire, 1956.

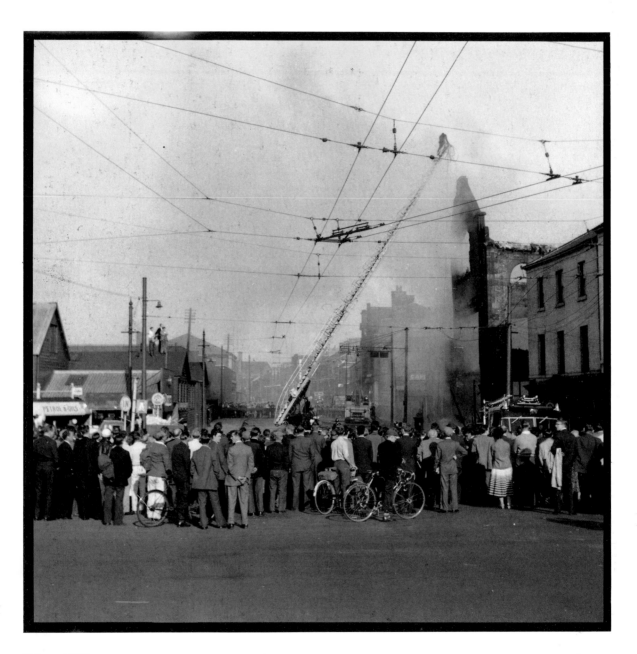

17 August 1959.

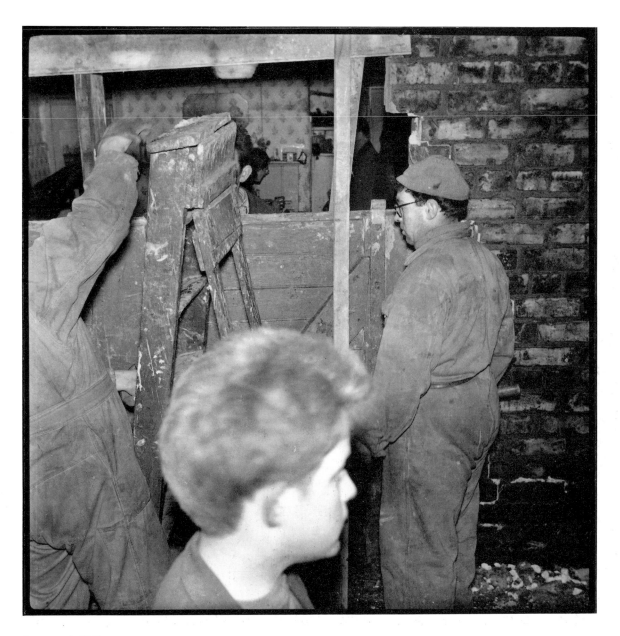

Lorry crash, 1960.

61. Aftermath of a fire.

62. Bell's timber yard on the corner of Railway Street, all the wood had caught fire. I was going down to the town on the bus with some friends, so we all hopped off and went round to look at the fire, I had the camera with me and took a few snaps of the firemen at work. That was after I got caught without it when there was that fire in Trafalgar Street, that was a really good fire that I missed. The fire-engine's called a Leyland Cub, they had Leyland Tigers which were bigger I was told.

63. I heard a screech outside the house, the car had cut right across the south side of the road into the path of the motorbike.

64. Another Ford Popular van and motorbike tangle on Railway Street. I remember someone getting one of these vans from a place along the road. He just got up to the top of Dunn Street and it went right through a telephone box. Wheel come off in his hand.

65. A scooter caught fire outside Cowies on Scotswood Road.

66. Under the trolleybus wires at tea time. People gathered whenever there was a fire, you'd always see a crowd. They've stopped on their way home from work or the shops, they're waiting for the gable end to fall down.

67. Here we have a hole in the bedroom of a house in Pine Street. A beer wagon from the Hope and Anchor Brewery ran backwards across the road into this lady's house. They used that in the *Chronicle*, though I didn't get much for it, 7/6d.

69. Stolen Jaguar that crashed in Gloucester Street, Sunday morning. A policeman jumped in front and waved his hands up and down thinking it would stop, all he got for his pains was a broken leg. The driver hopped it around the back lane. I gave the pictures to the polis.

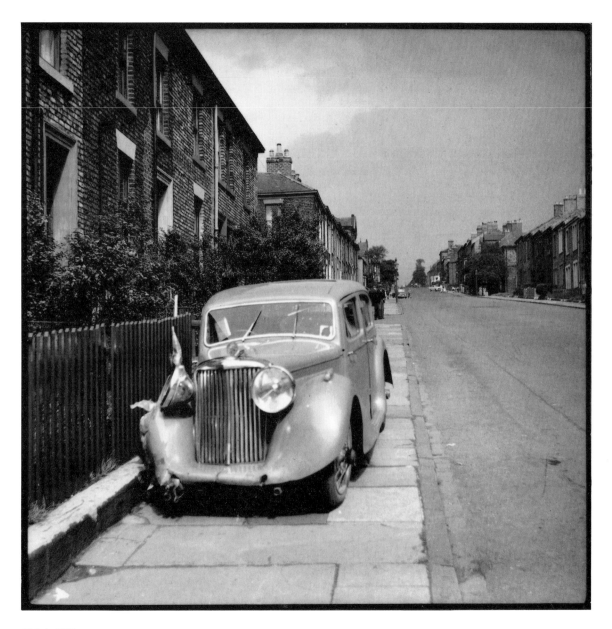

29 July 1958.

I never wandered far from Scotswood Road, you didn't need to, everything was there. Sometimes I went as far as my few bob would allow, to see what I could see.

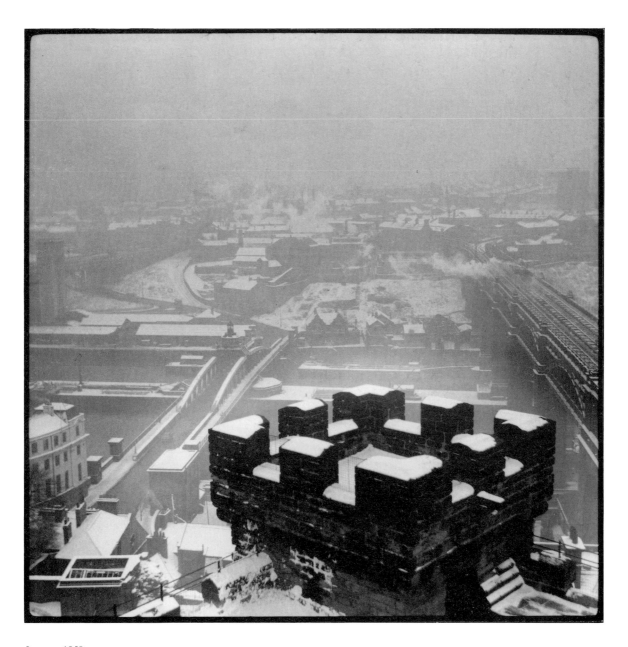

January 1958.

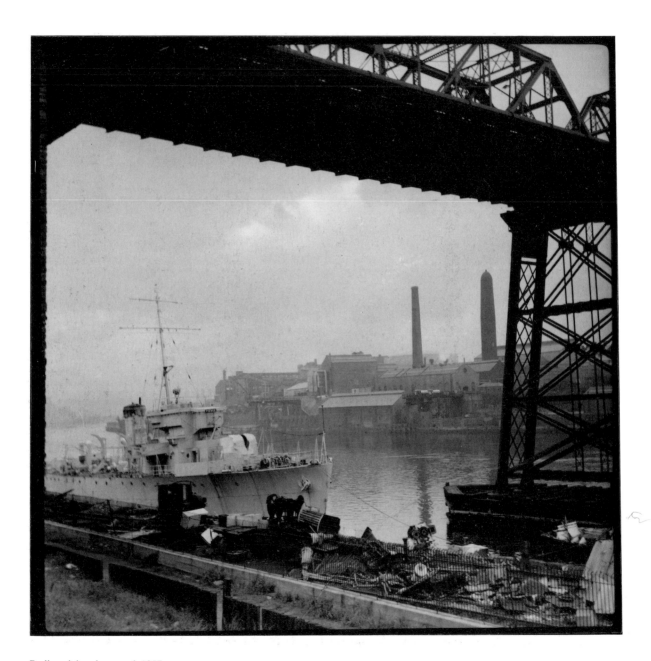

Redheugh breakers yard, 1957.

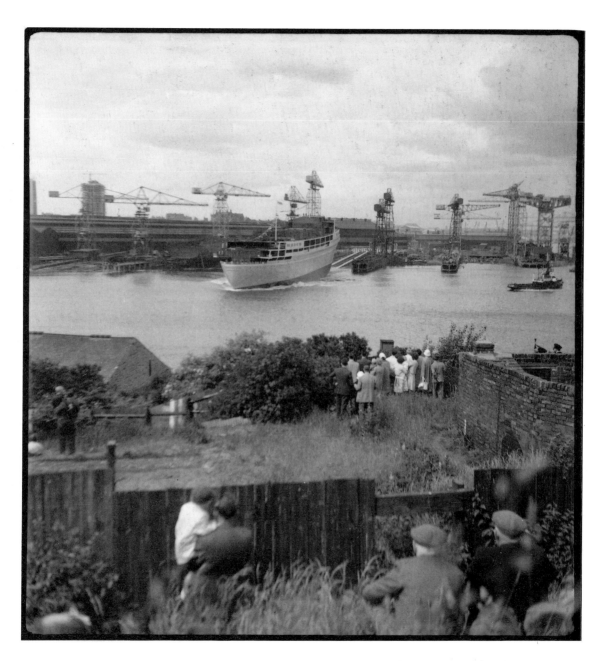

Swan Hunters, Wallsend, 27 June 1961.

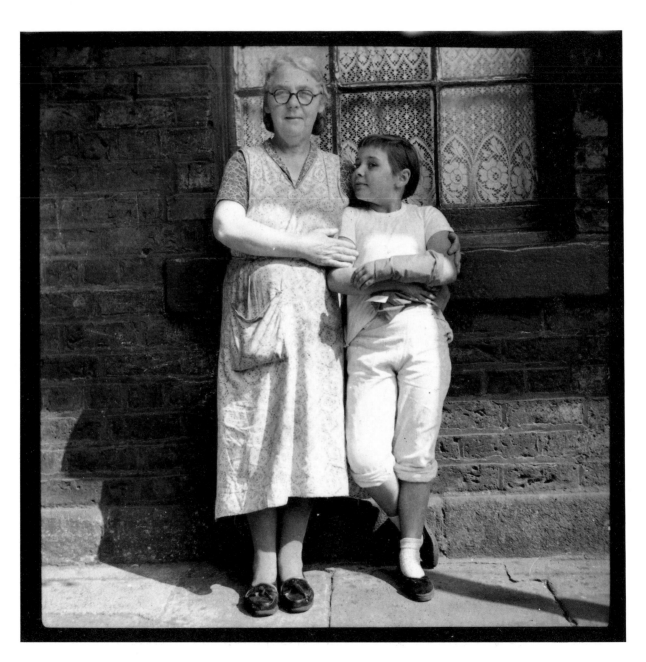

74 Victoria Market, July 1957.

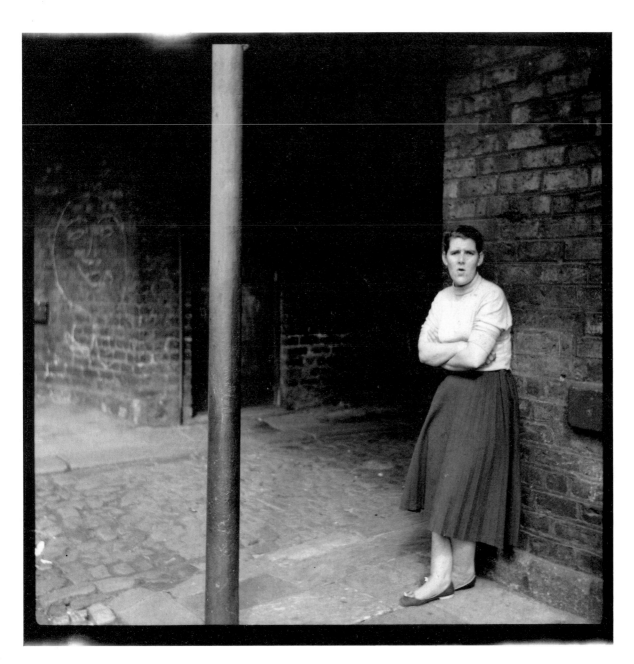

Victoria Market, July 1957.

71. Bottle Bank, Gateshead, from the Newcastle keep.

72. An obsolete corvette ready for breaking up at the yard underneath the old Redheugh Bridge. Across the river on the Scotswood side, Elswick leadworks and the 1778 shot tower.

73. The Queen Mother launched the North Star at Swan Hunters. People watching from the south side, at Bill Quay.

74. The Victoria Market on Gibson Street, grandmother and granddaughter.

75. The Victoria Market was a courtyard with balconies on all four sides, it was an enclosed community all of its own reached by a passage.

77. Tollgate keeper's house, Redheugh Bridge, from Potters Lane.

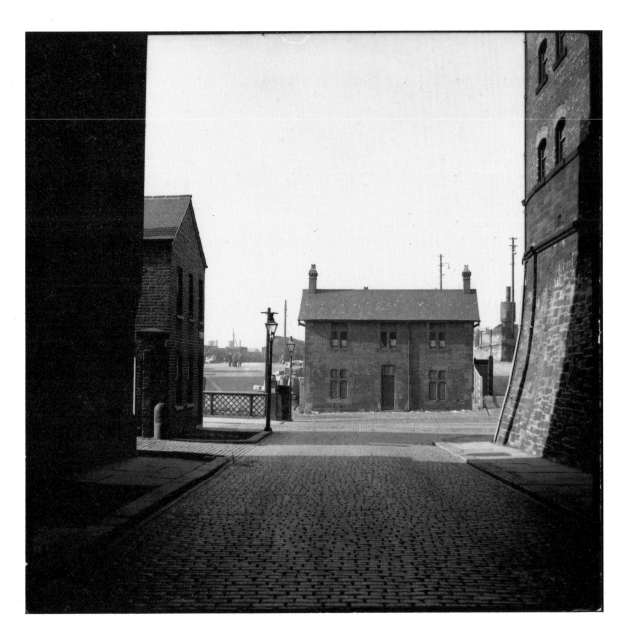

September 1957.

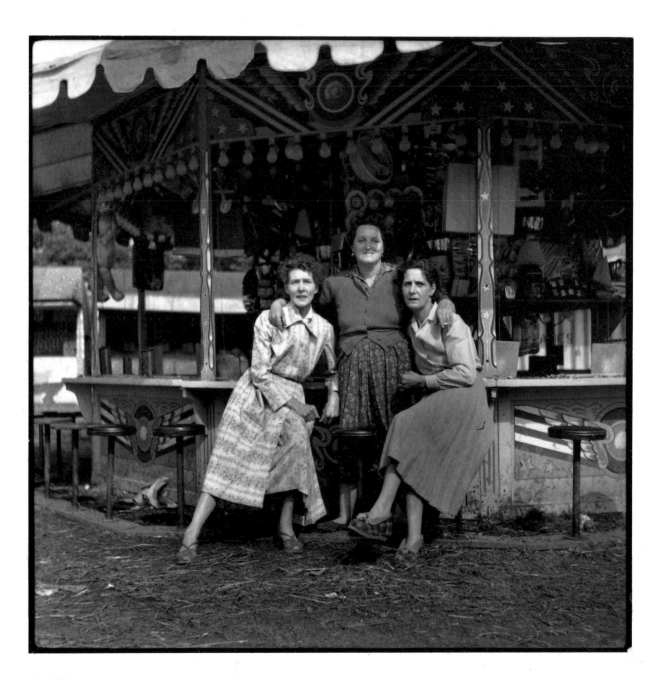

78 July 1957.

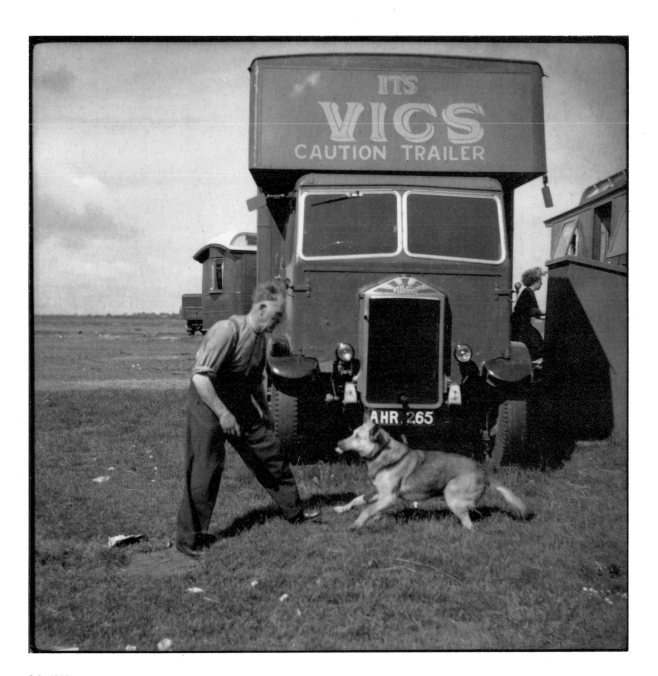

July 1957.

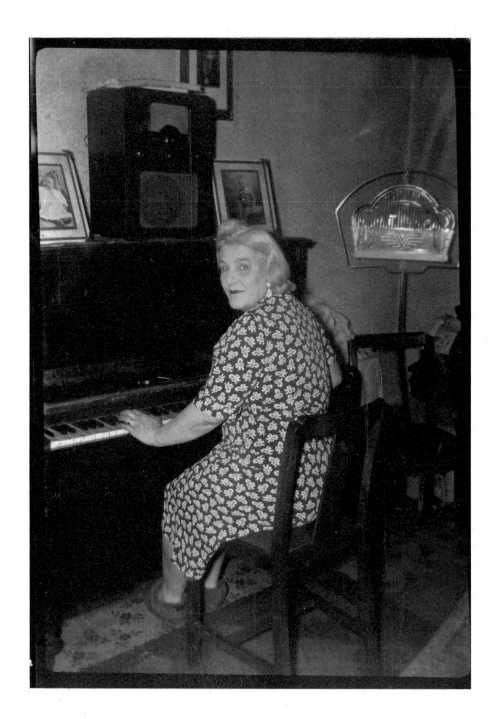

Dora Charlton, 1955.

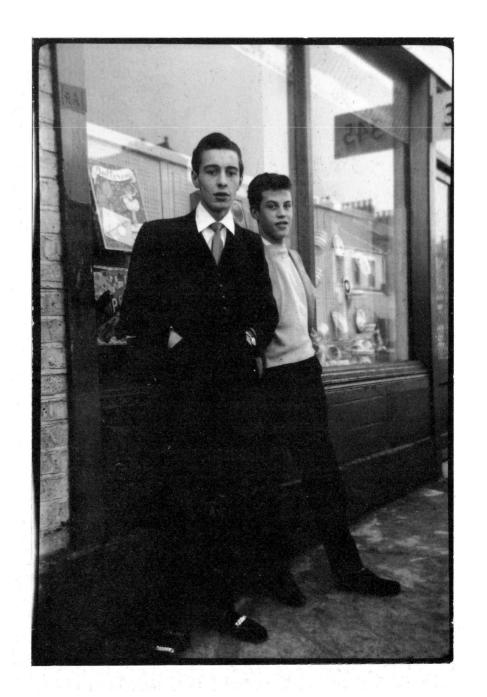

September 1958.

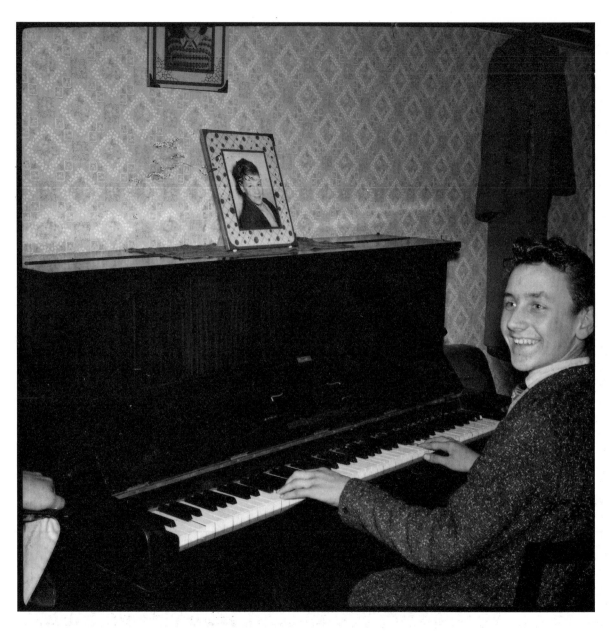

Interior, 1957.

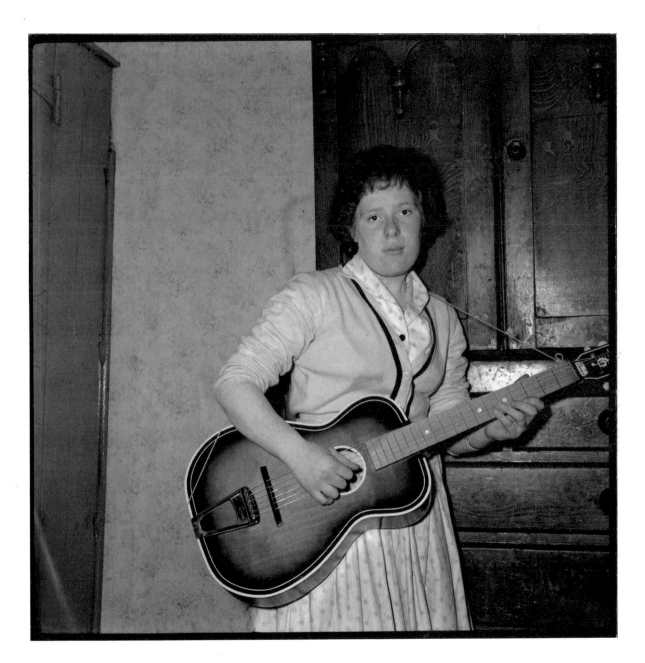

October 1958.

78. Three Scotswood Road women. A few people used to go up to the Hoppings to work the stalls to get a bit of pin money. For others it was the only holiday outing of the year.

79. Vic ran one of the bingo stalls, he's playing with his alsatian on the Town Moor site.

80. Dora in her living-room. Actually, she couldn't play the piano.

81. Two lads dressed up and ready to go out, outside 345 Scotswood Road near where they lived. It used to be a pawn shop, here it's a pot shop.

82. Charlie playing the piano, Delaval Road.

83. Edie Jardine.

85. A view of Weatherley Street from Hare Street.

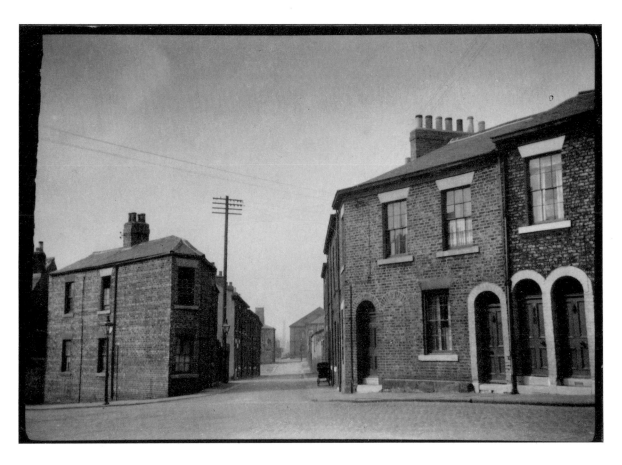

July 1956.

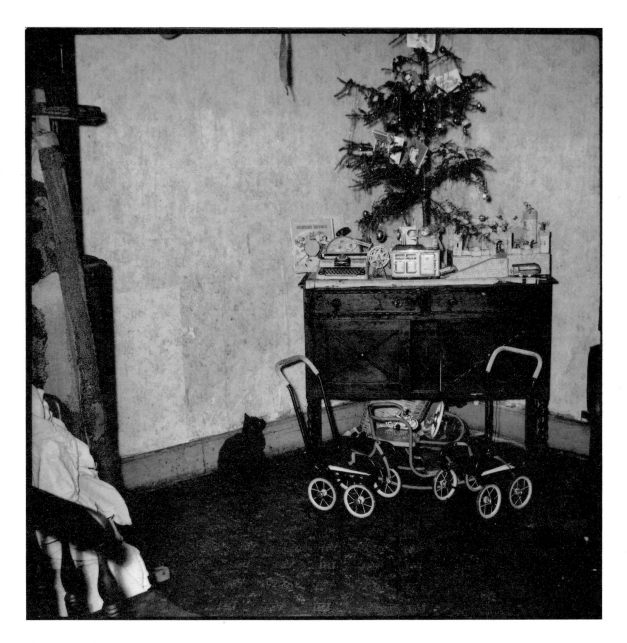

Christmas Eve 1958.

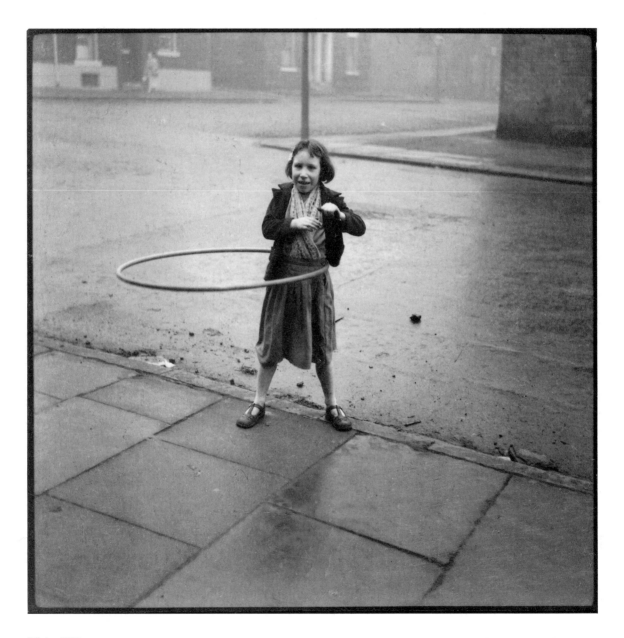

Winter 1957.

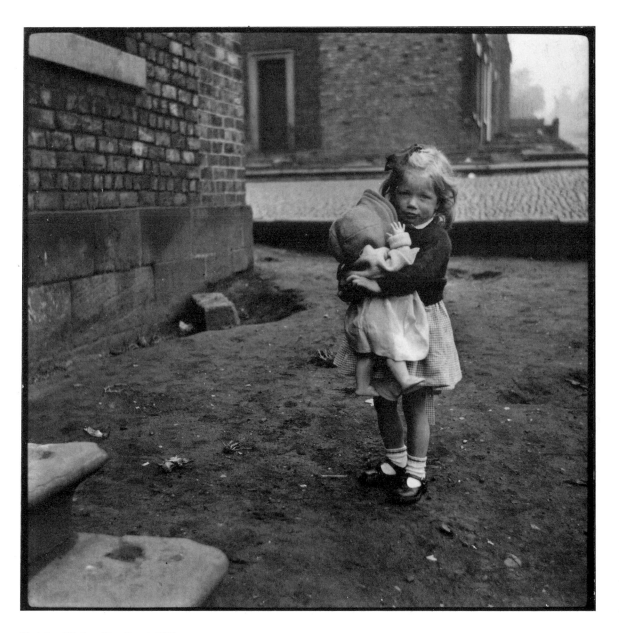

Christine Winters, Pine Street, 1957.

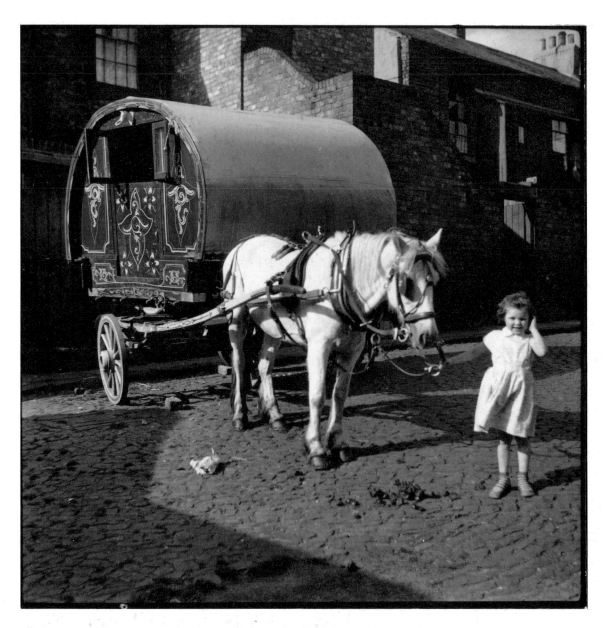

April 1957.

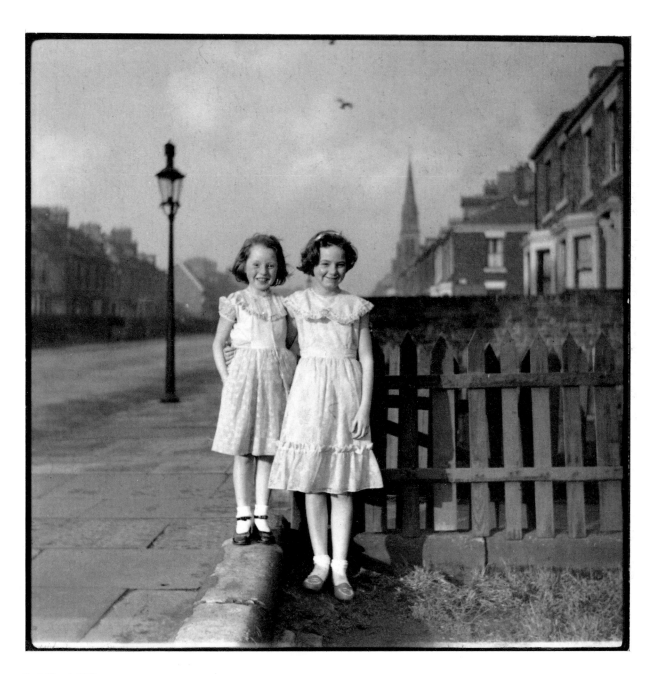

Park Road, 1959.

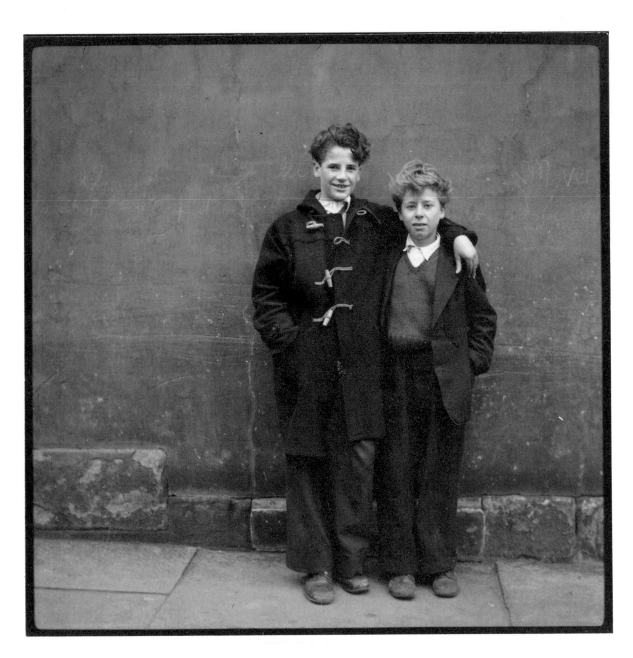

Snuggie Sample and Derek Wall, 1957.

87. Christmas Eve, a friend's house in Gloucester Street, with all the toys set out for the children under the Christmas tree. A lot of Scotswood people like this photo because it reminds them of what it was like when they were young. This was taken with a flash. In those houses I believe, if my memory serves me right, it was just gaslight, lots of houses didn't have electricity by then.

88. There was that hoola-hoop craze. Before they started pulling the houses down, they used to play marbles and with hoola-hoops and whipping-tops, and children's games like hop-scotch that all seem to have vanished since the tellies came out. This is Gloucester Street, I don't know who the lassie is.

89. This is Christine, she lived just across Pine Street on the corner. There were gardens here before the war, but what spoilt the place was that fad for pinching all the railings for scrap, after that all the gardens behind fell to waste ground. When my father used to work on the railway down towards Bridgend there was this big heap of scrap that had been collected on the side of the railway and it was still there after the war, never got touched. It just gave people the impression they were doing something for the war effort.

90. Maureen Liddle with her father, Jock's horse and caravan in a back lane behind Scotswood Road.

91. Angela Pearce, left, and Pat Norman in their Sunday best. I saw the seagull flying about and waited until it reached the middle, to make the picture better.

92. Two friends in a Scotswood Road back street.

95. November 5th, that was the general scene in those days, bonfires everywhere. This was in Back Scotswood Road, its real name was Oak Street but it never went by that name.

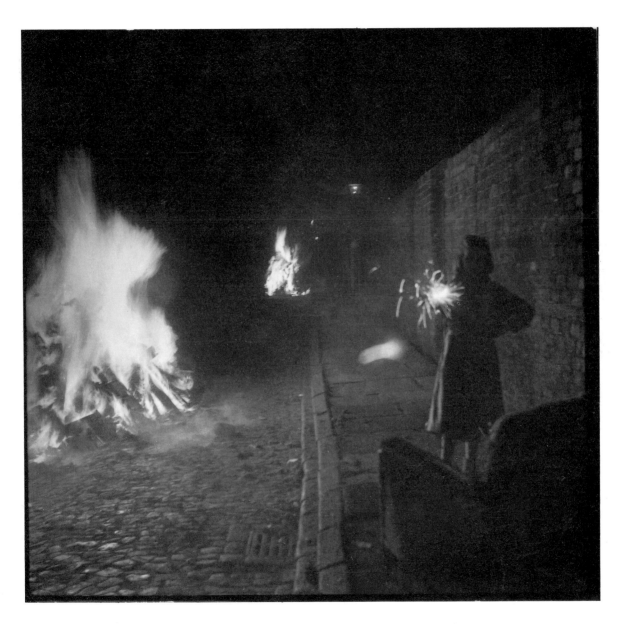

Christine Reynolds, 1959.

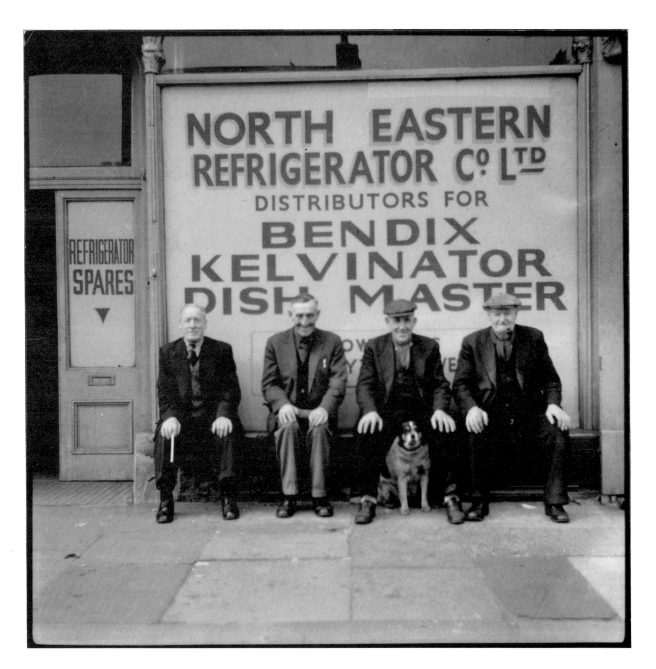

The Four Just Men. Scotswood Road, August 1957.

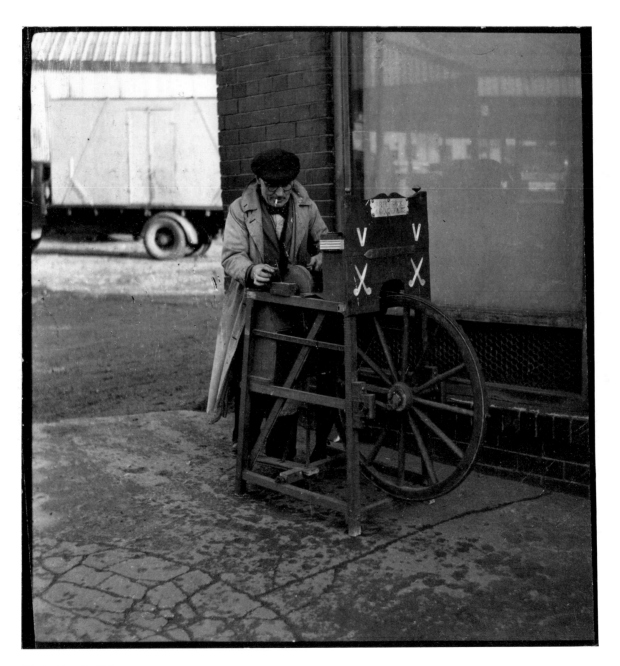

98 Charles Francis, 1957.

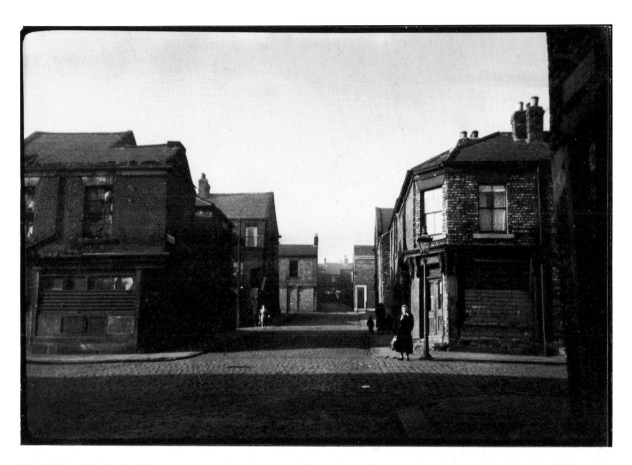

Laurel Street, March 1956.

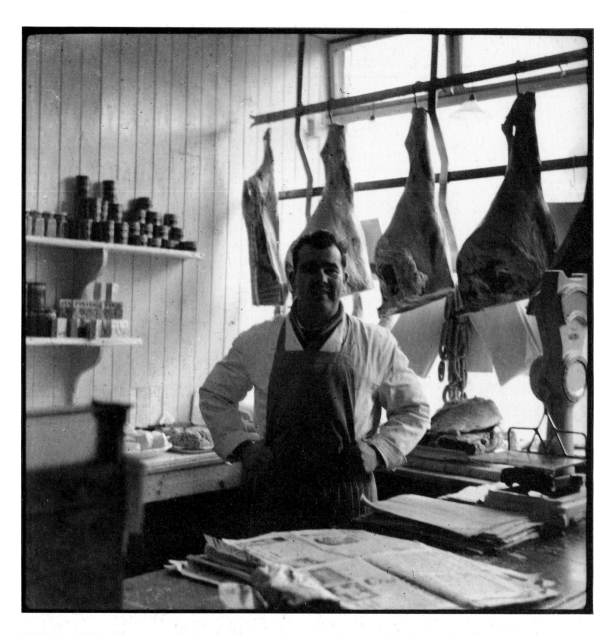

Mr Wallace, 1957.

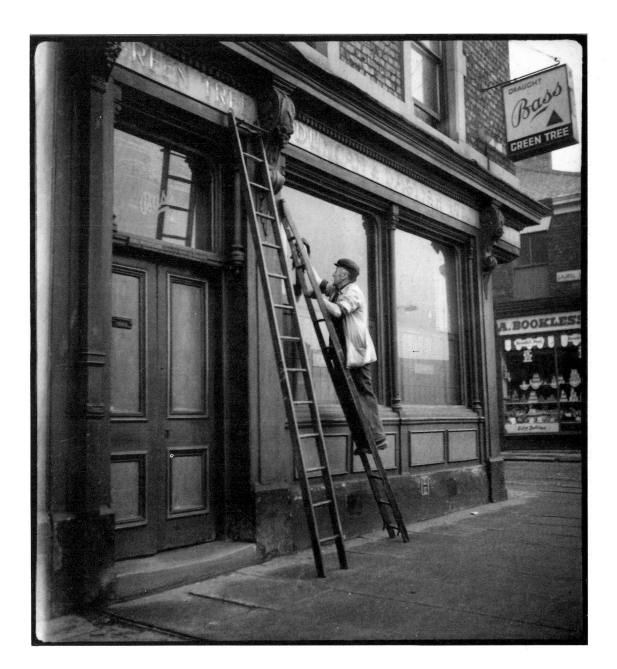

Mr Ferguson, 1958.

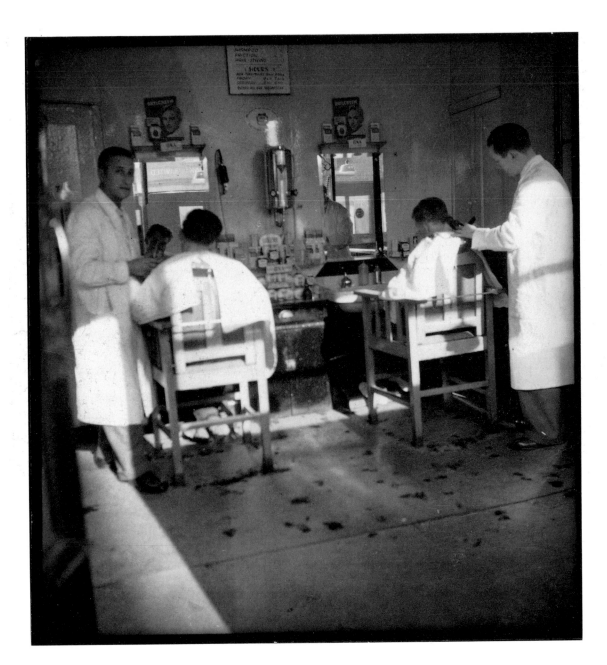

Frank's, Gloucester Street, 1957.

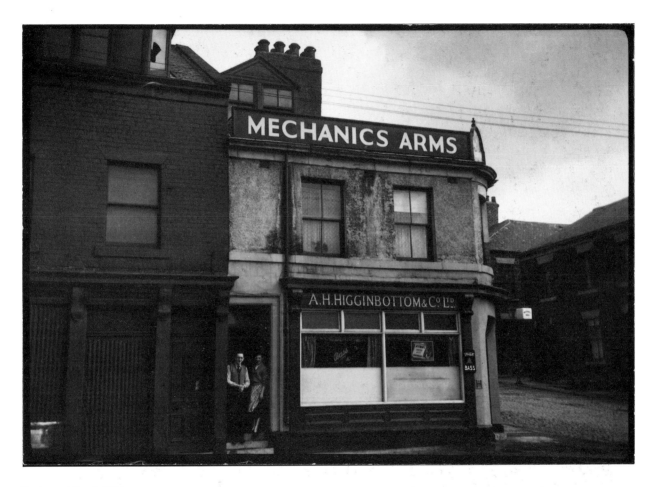

Scotswood Road, 1956.

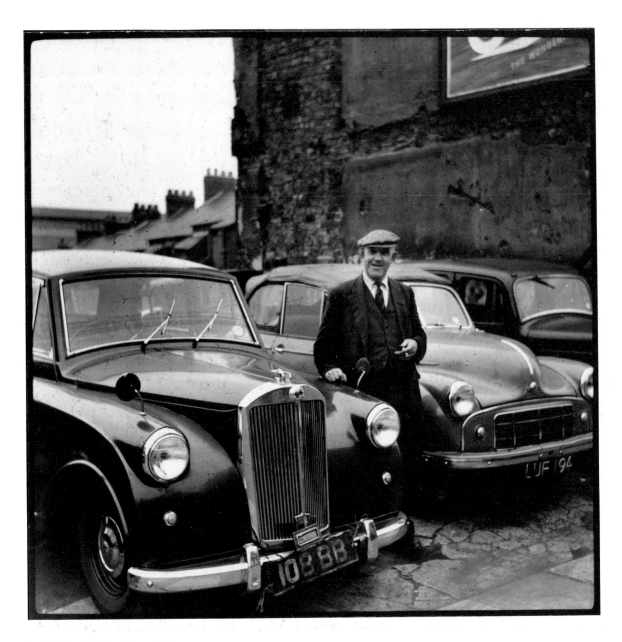

Sandy Skinner, Water Street, 1959.

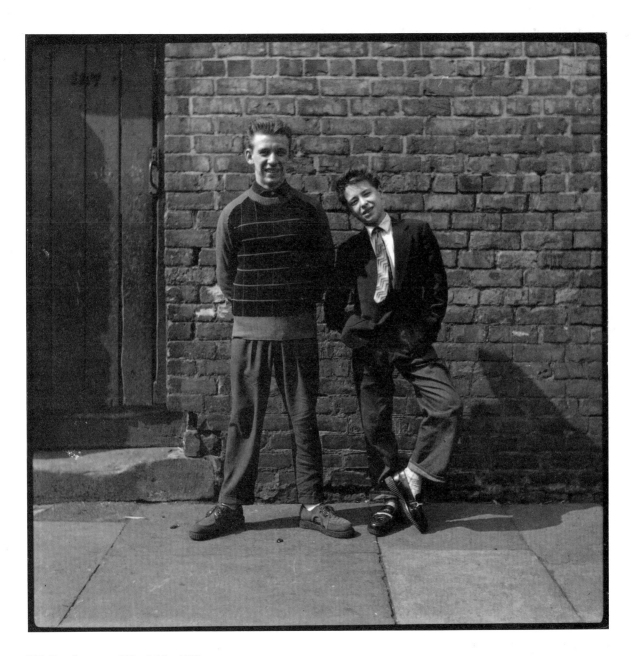

Billy Prendergast and friend, May 1957.

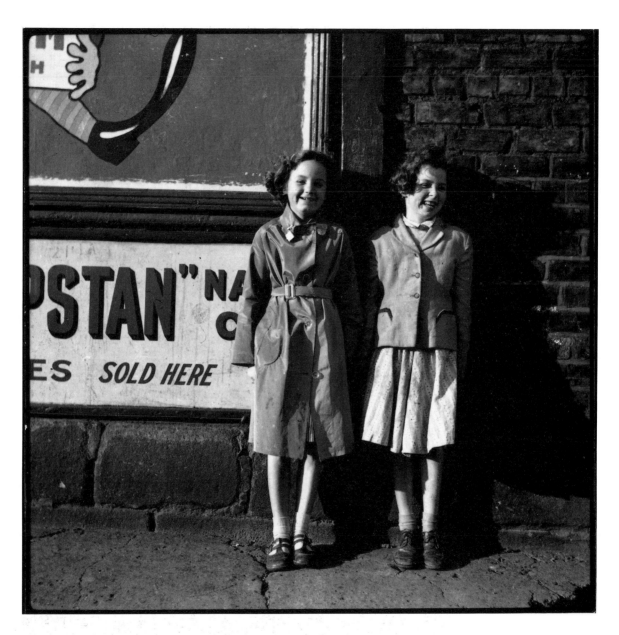

Pat Norman and friend, 1958.

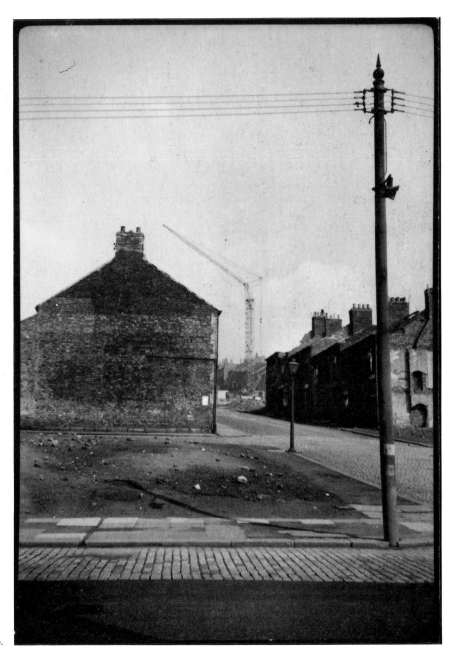

Noble Street, 1956.

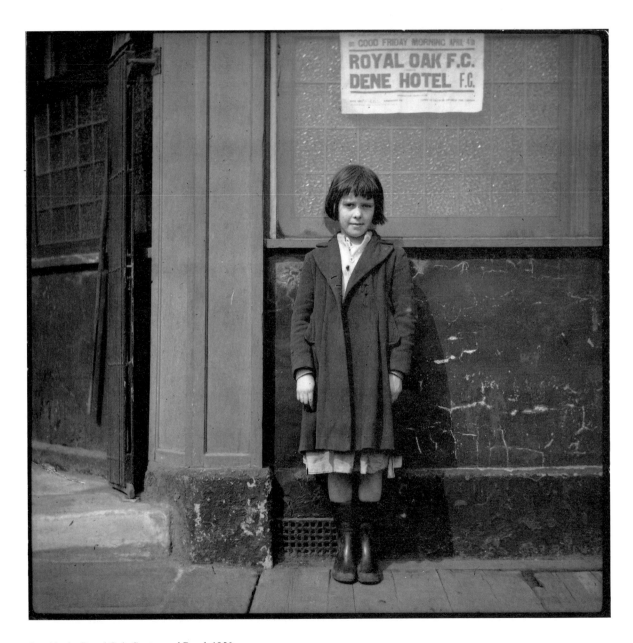

Outside the Royal Oak, Scotswood Road, 1956.

97. Ned Campbell, Joe Wylie, Bob Atkinson and Bob Wilson, where they usually sat, waiting for the pub to open.

98. Mr Francis the knife-grinder, one of the last street traders of his kind. That's just opposite Marlborough Crescent bus station, it's a car depot now but it used to be the killing-shop along Scotswood Road for the cattle market.

99. Looking up Laurel Street across Sycamore Street. The boarded-up building on the left used to be the Engineers Arms pub. The post-war years saw a lot of businesses off.

100. Mr Wallace was the manager of Dunn's on Maple Street and Scotswood Road corner. He emigrated to Australia but came back. There were four or five butchers on Scotswood Road. You could afford meat then, a decent joint once a week, and things you can't get now like pigs' chitterlings, they've all disappeared. Pigs' trotters you don't see so much now, not even in the market, all them things are probably going into the dog food, they get more profit that way.

101. Mr Ferguson cleaning the Green Tree on Scotswood Road, next to Laurel Street. He used to do all the big windows near there. I never saw him with a cart, he always carried the ladders.

102. The door was open, the sun streamed in, as I passed by. 'How about a photo lads?' I've forgotten who the customers are, dozens who see this will think it's them.

103. To the west of Rendel Street, the Mechanics Arms.

104. Sandy with one of Maurice Wilson's poshest second-hand cars. He didn't work there, at one time he used to be a long distance lorry driver. You know what they used to say in the old books, he'd make a good flyer because he's got big ears. That's what they used to say in the First World War.

105. Billy Prendergast and his mate showing off their new brothel creepers in the back lane at 127 Sycamore Street. You can see they were pleased with themselves, they thought they were dressed quite posh. That was the general teddy boy sort of wear, like you see them now when they are out, very proud because they've got red hair. Once I had a coat, it was sky blue with little white spots all over it, and people said you can't wear that sort of coat because it's too young for you but I wore it just the same.

106. Outside Hutchinson's baccy shop on Scotswood Road, a few shops along from Park Road.

107. Work begins on the notorious flats that became Tyneside's biggest post-war housing disaster.

108. She wanted the photograph for her grand-father who was going blind.

111. They were waiting to hear about moving and wanted a picture of themselves with the old house to remember it by. The house was spotless inside, unlike what the wartime salvage men had left – rough stumps of the railings they took away. Strange, that they also left the latched gate, leading nowhere.

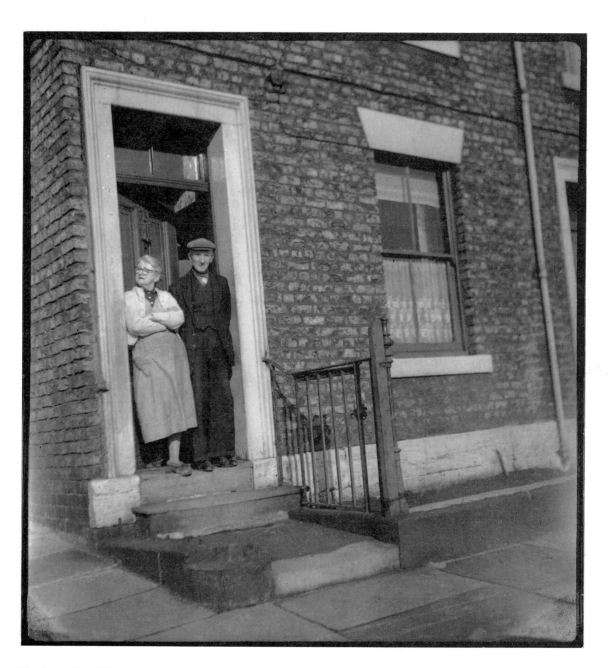

Pine Street, July 1959.

The community had been built up over a hundred years. Now it was being split up, and people had to make a new life in strange places. Those who hung on till the last had to put up with the noise and dust of the demolition, until there was nothing left worth hanging on for.

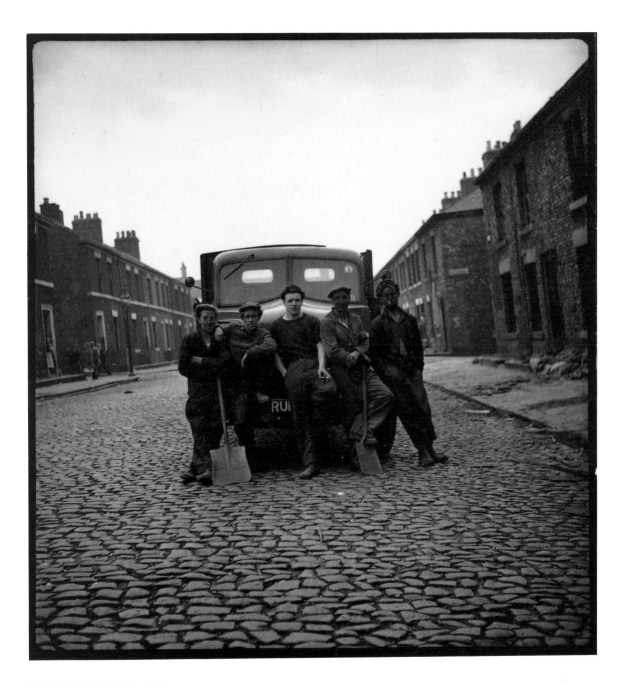

Pine Street, 21 September 1960.

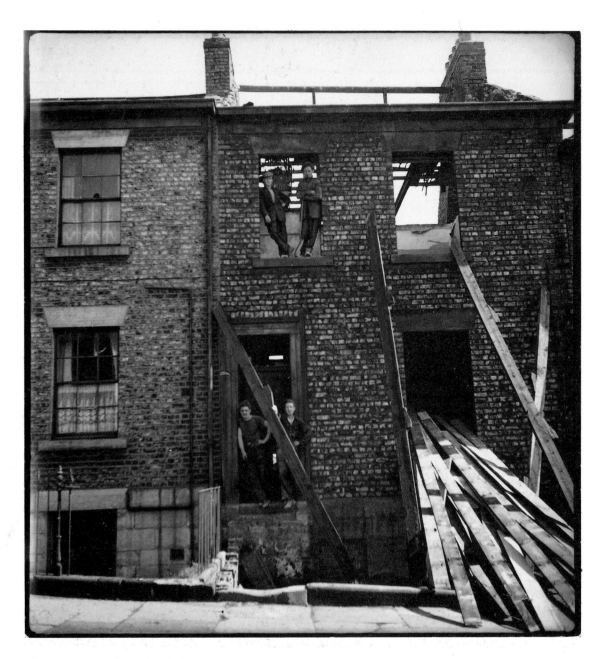

Gloucester Street, 23 September 1960.

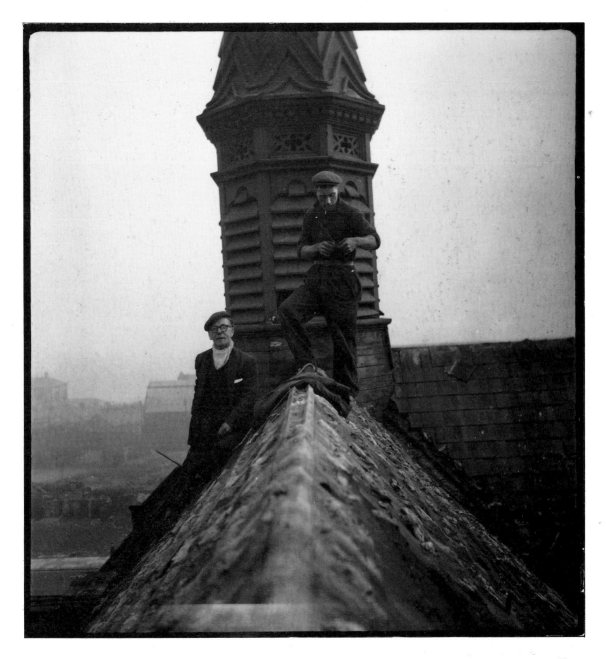

St Stephen's, Tulloch Street, 15 September 1960.

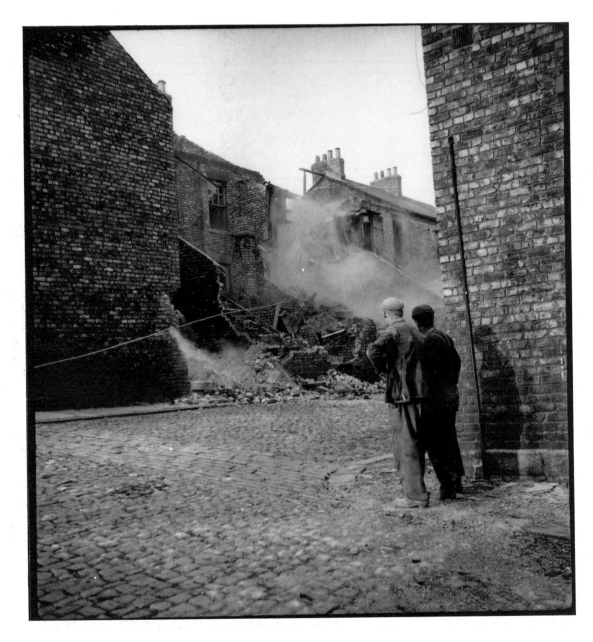

October 1960.

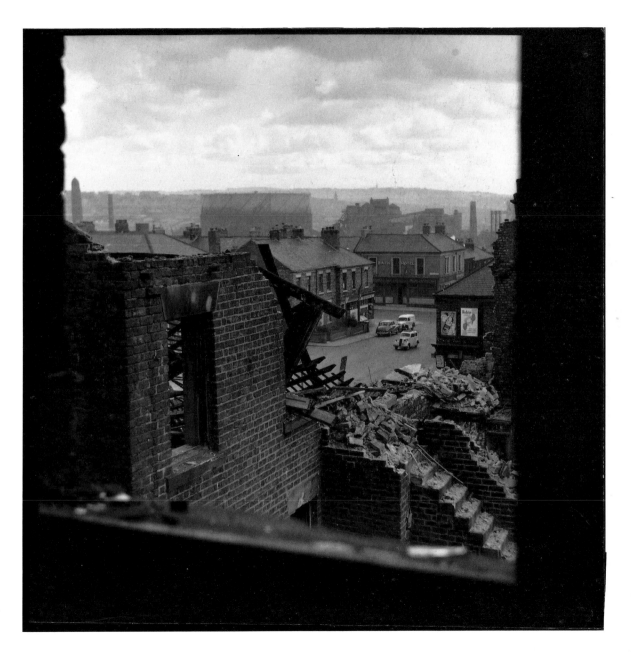

19 August 1960.

113. It's ironic that these men made my record of the demolition possible. They bought prints of themselves that I'd taken, and I made enough to buy more film to carry on the job. They wanted the photos to take home to show the kids, their dad driving a digger and that.

114. The same gang, hard working, hard drinking, acrobats. There is still someone living next door.

115. Vic Summers with the glasses, and Ned Turnbull. Vic took the picture of me at the front of the book. Across Scotswood Road behind them, the leatherworks run by Sir Ralph Richardson's family, and through the mist, the Tyne.

116. The house down at the end of the cable is on Pine Street.

117. View from rear window of 107 Pine Street on my birthday, 1960. The rafter points to Frank's the barbers and Gibson's shop. The Bath Hotel is opposite across Scotswood Road, named not after the city but what you could get there once after a day in the muck at Armstrongs.

119. They forgot that people left in the houses still standing had to get around using the cleared streets. Complaints were put in about the mud and the men began sweeping up.

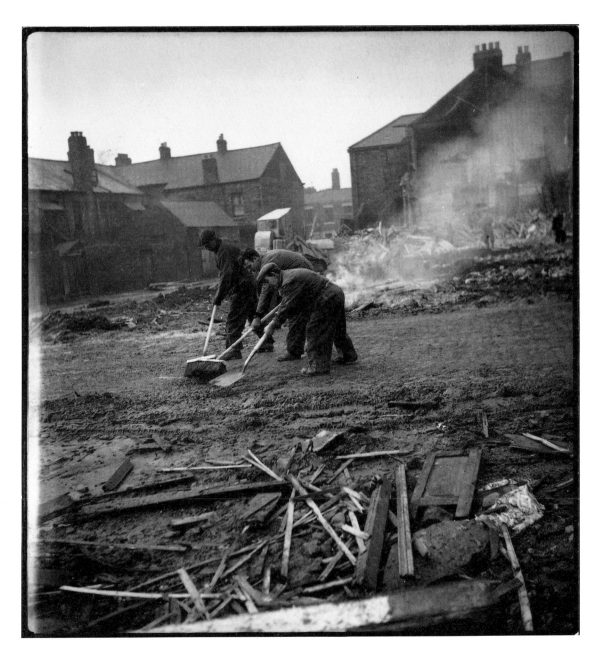

Laurel Street, 14 June 1959.

Opposite the Ord Arms at the end of the road, the Scotswood suspension bridge. Its dismantling was the final act, the new bridge swept up the last of the old community, including magnificent buildings like the Arms. There was a campaign to preserve the old bridge as a monument, but it got nowhere.

121. No one lived on the land behind when it was built so the fourth face of the clock was left blank.

122. Construction began on the new bridge on 30 August 1965. This is from St Margaret's Road.

123. They had a man on a cradle who burnt the support wires off. I've some photos of the cables falling but it was too quick. I only had a box camera then. I was standing on top of that tower, I always go where I'm not supposed to.

124. The Willows, below 'Dr' Hay's the chemist, whose potions cured all.

125. The land once belonged to a director of Armstrongs, W.D. Cruddas, who lived at Haughton Castle. Haughton Court is being built and Kings Meadows flats. Kings Meadows was a pretty island on the Tyne, with a pub on it, which Armstrongs had dredged away to get their battleships down the river.

126. In 1962 I watched Hugh Gaitskell and Dan Smith unveil a prize-winning bronze sculpture outside The Willows. We nicknamed the statue 'The Monstrosity'. It wasn't there long, someone said it had been stolen and melted down for scrap.

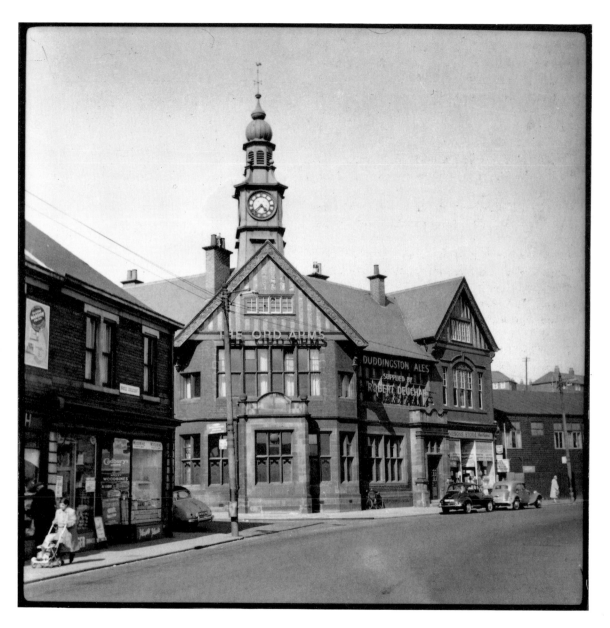

Ord Arms, 1958.

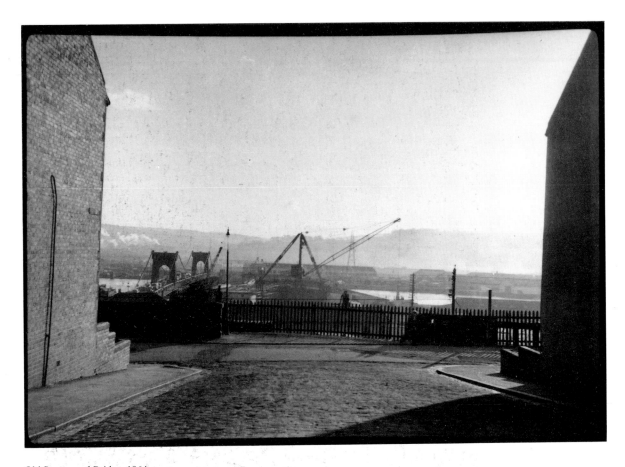

Old Scotswood Bridge, 1964.

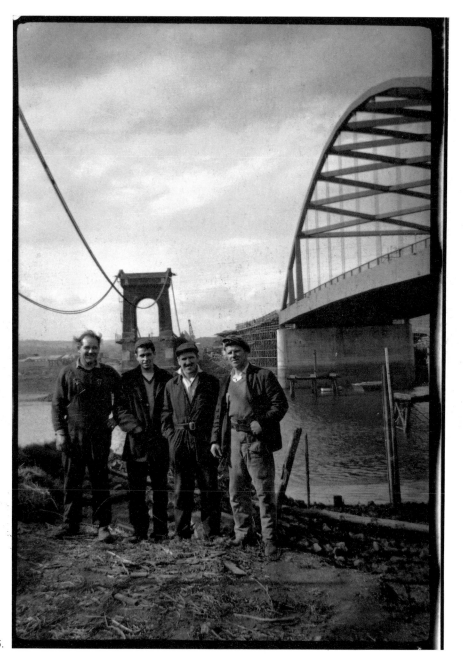

Demolition men, 1965.

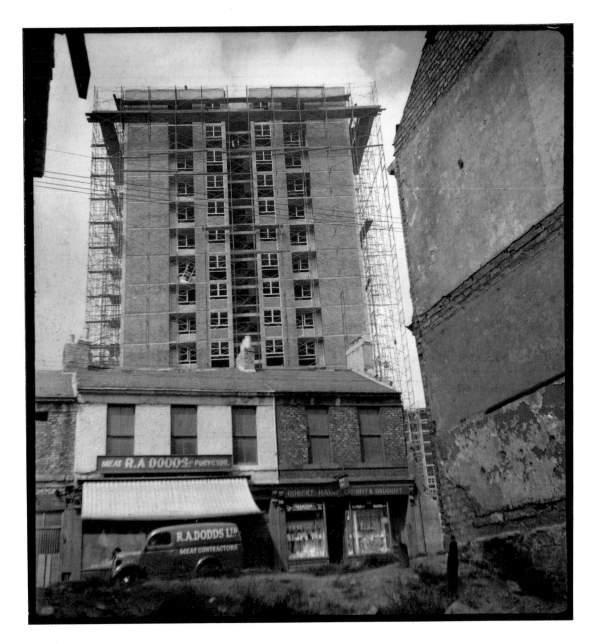

July 1960.

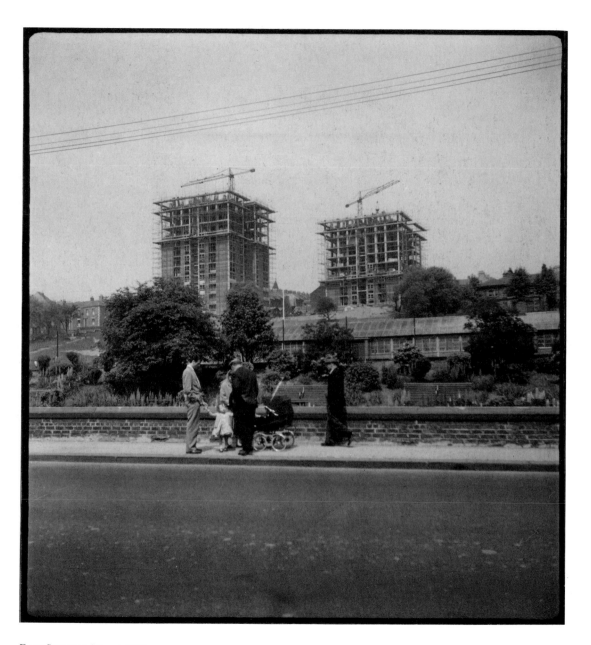

From Scotswood Road, 1960.

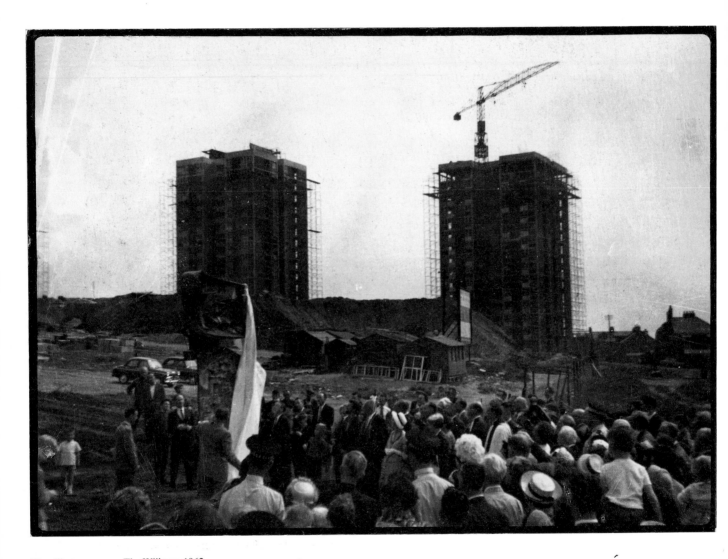

Unveiling ceremony, The Willows, 1962.

126

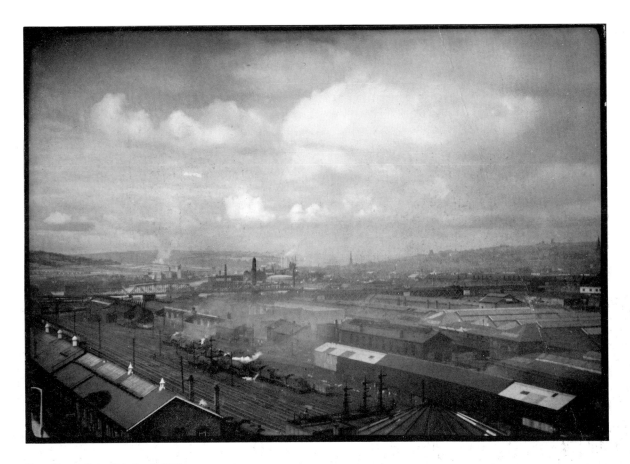

From Barnes flats, Gateshead, 1956.

Most people wanted to move, it was a kind of adventure going to a new promised land idea. The promised lands weren't always what we'd hoped for, we were either scattered in high-rise flats or driven out to soulless estates miles from anywhere. Perhaps the politicians who strove to produce new homes at all costs, and the big contractors who wanted to make a fortune out of it all, were the only ones who won in the end.

Jimmy Forsyth Collection

Prints of the photographs in this book can be ordered at reasonable prices from the Jimmy Forsyth Collection at Benwell Library in Newcastle. For details, write to: A.D. Walton, West Newcastle Local Studies, Benwell Library, Atkinson Road, Benwell, Newcastle upon Tyne NE4 8XS. Please quote negative numbers in all correspondence. A substantial collection of pictures of West Newcastle by other photographers is also held at Benwell.

All enquiries relating to the publication or reproduction of photographs from this book in any form should be addressed to: Rights Department, Bloodaxe Books Ltd, P.O. Box 1SN, Newcastle upon Tyne NE99 1SN.

PAGE	NEGATIVE NUMBER				
23	V8/30	57	V4/46	92	P5/97
24	V2/57	59	V15/131	95	V15/100
25	V9/48	61	V14/112	97	P6/40
26	P7/27	62	V15/96	98	P6/70
27	P5/68A	63	V11/81	99	V3/51
28	P4/80	64	V16A/49	100	P5/131
29	P4/110	65	V12/9	101	M22A/112
30	M23/113	66	V14/119	102	M26/118
33	V9/118	67	V16A/88	103	V5/33
	top to bottom	69	V10/72	104	P5/3
34	V3/61, no negative, V5/46	71	V9/72	105	P4/50
35	V3/39, V6/16, V7/83	72	NN./1	106	P5/94A
36	V5/38, V3/37, V5/44	73	M/6	107	V3/97
37	V3/42, V5/31, V5/35	74	P7/14	108	P6/38
38	V7/81, V5/38A, V3/35	75	P7/19	111	M18/105
39	V5/37	77	P9/31	113	V16B/66
41	V15/68	78	P6/96	114	V17/45
42	P4/30	79	P6/114	115	V17/5
43	P5/139	80	P1/2	116	V16/131
44	P7/24	81	P7/58	117	V16B/21
45	P7/109	82	P6/89	119	V18/149
46	P4/112	83	P5/52	121	V12/106
47	P4/41	85	M27/119	122	M24/39
48	V14/66	87	V9/64	123	M40A/66
51	P7/78	88	19A/108	124	V16A/97
53	V9/69	89	P4/76	125	M/120
54	V10/38	90	P4/114	126	M/16
55	P1/1	91	P7/145	127	V5/83
56	P6/92				